IMAGES
of America

BOONSBORO

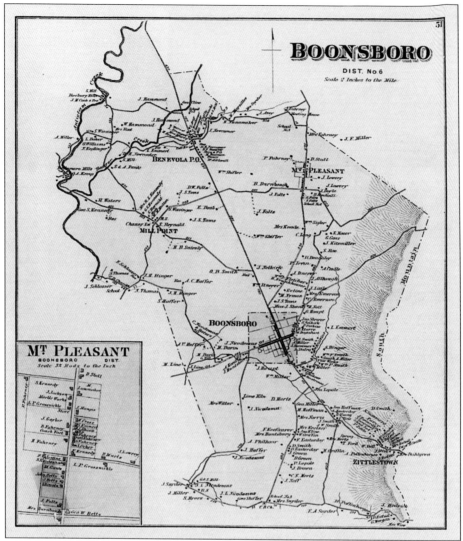

The 1877 community reference book, *An Illustrated Atlas of Washington County, Maryland*, contains this map of Boonsboro election district six, with an 1870 census population of 2,579. The unincorporated villages of Benevola, Mill Point, and Mount Pleasant are shown to the north of Boonsboro, and the village of Zittlestown is southeast of town on the western slope of the South Mountain range. The Antietam Creek marks the Boonsboro election district's northwest boundary, and the top of the South Mountain range creates the district's southeast boundary. Stretching 40 miles across Maryland from Virginia to Pennsylvania, the South Mountain range is also the border between Washington and Frederick Counties. (Courtesy of the Washington County Free Library.)

ON THE COVER: In casual dresses and standing in front of 1930s gasoline pumps at the Babington Motor Company Chevrolet dealership are, from left to right, Margaret Poffenberger, Lena Babington, and Vivian Babington. Mr. Babington wears a flat cap and open sweater and stands behind the latest mid-1930s Chevrolet model at his dealership on the west side of South Main Street. Babington's carried Gulf, Sunoco, Betholine, Terminal Station, and Rickfield gasoline. (Courtesy of the Boonsborough Museum of History.)

IMAGES
of America

BOONSBORO

Tim Doyle and Doug Bast
Foreword by Nora Roberts

ARCADIA
PUBLISHING

Copyright © 2012 by Tim Doyle and Doug Bast
ISBN 978-0-7385-9239-8

Published by Arcadia Publishing
Charleston, South Carolina

Printed in the United States of America

Library of Congress Control Number: 2012931384

For all general information, please contact Arcadia Publishing:
Telephone 843-853-2070
Fax 843-853-0044
E-mail sales@arcadiapublishing.com
For customer service and orders:
Toll-Free 1-888-313-2665

Visit us on the Internet at www.arcadiapublishing.com

To all who look to the past to enrich the present and inform the future

CONTENTS

ACKNOWLEDGMENTS

This book would not exist without the personal heartfelt commitment of individuals, their organizations, their publications, their computer connections, and their private and public collections.

Leading the way as the primary resource for the images and information in this book is coauthor Doug Bast's private, nonprofit Boonsborough Museum of History. But the expanding queue of gracious and learned contributors and supporters of Images of America: *Boonsboro* also includes the following individuals and institutions: *New York Times* bestselling author Nora Roberts and her publicist, Laura Reeth; Boonsboro-area natives Ruann Newcomer George and Edwin Itnyre; John Frye and Jill Craig and their Washington County Free Library archives; Linda Irvin-Craig and Catherine Landsman and their Washington County Historical Society archives; Dan Spedden, the superintendent of South Mountain Recreation Area; and John A. Miller, South Mountain State Battlefield historian.

Additional behind-the-scenes assistance has been provided by the Town of Boonsboro, the Boonsboro Free Library, the Bowman House and Boonsboro Historical Society, the Boonsboro Trolley Museum, Turn the Page Bookstore, Paula S. Reed and Associates, Hagerstown Community College, the Central Maryland Heritage League, and scores of other valuable resources.

FOREWORD

I live in southern Washington County, Maryland. My land is rocky and wooded and quiet and, for me, perfect. I am often asked why I live here when I could live anywhere. The answer is simple: because this is home.

I raised my sons here and now have the gift of watching my grandchildren—four at current count—grow up in the wooded hills where they can run and play and explore along curving streams in an area steeped with history.

Both my sons graduated from Boonsboro High School and now tell stories—some I was much better off not knowing about at the time—of their adventures. They have good memories of growing up here: some funny, some sweet. When he was in Boonsboro Middle, my youngest, Jason, played one of the King's sons in the Boonsboro High School production of *The King and I* and fell in love with theater. He is a lighting designer, making his living doing what he loves, and he met his wonderful wife, Kathryn, when they both studied theater at the University of Maryland.

In high school, my oldest, Dan, delivered pizza for Asaro's, a Main Street staple. When Jim and Sherry Asaro decided to sell, Dan bought the business. He now owns and operates Vesta Pizzeria on the square.

My husband, Bruce, has owned and operated Turn the Page Bookstore on Main Street for 16 years and counting. Both my husband's and son's businesses occupy lovely old pre–Civil War buildings—buildings that saw war and recovery, that stood as the Battle of Antietam and the Battle of Boonsboro raged. They still stand, a testament to endurance, marking the history of Boonsboro and the country.

A few years ago, we bought the old Boone Hotel, also on Boonsboro's square. This, the oldest stone building in town, has endured and survived and shines today as Inn BoonsBoro, once again a place for travelers to stop and rest, to base as they explore all this town and this special area have to offer. In September of this year, Dan married his beautiful Charlotte in the courtyard of the inn, and the town celebrated with them.

That is Boonsboro. That is community.

Boonsboro is a place that does not forget its long and storied history. It is a place where you can walk down Main Street and stop to chat a moment with a neighbor or fellow merchant.

I cannot think of anyone who knows more about Boonsboro's history or sense of community than Doug Bast. When we were rehabbing the inn, we had only to ask Doug if we wanted to know some detail, some story, and some piece of history or lore. In the following pages, Doug and Timothy Doyle will tell—and show—what Boonsboro is, where it came from, what all its lovely old buildings have seen, and what its people endured and accomplished.

Where it came from—as with my boys and my family—helps determine where it is going. Why do I live here? It is home. And home has deep, strong roots.

—Nora Roberts

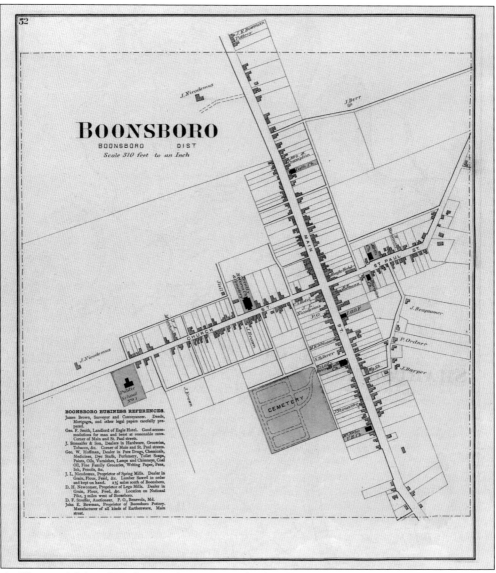

An *Illustrated Atlas of Washington County, Maryland*, published in 1877, includes this Boonsboro town map, which shows, in the lower-left corner, "Public School No. 7" and the names and occupations of eight "Boonsboro Business References." John E. Bowman's Boonsboro Pottery business is on the east side of North Main Street at the top of the map. Farther south on the east side of North Main Street is St. James Catholic Church, while Trinity Evangelical Lutheran and Mount Nebo United Brethren in Christ Churches are on the west side of South Main Street. The Trinity Reformed United Church of Christ building and graveyard are on the north side of Church Street—Potomac Street today—near the town jail. A Methodist Church is on the north side of St. Paul Street, and the First Christian Church (Disciples of Christ) is on the south side of St. Paul Street. At Boonsboro's center square, the Eagle Hotel is on the northeast corner of Main and St. Paul Streets, and the United States Hotel is on the southwest corner of Main and Church Streets. The Independent Order of Odd Fellows building is on the east side of South Main Street near the center of town. Boonsboro's 1870 census population was 835. (Courtesy of the Washington County Free Library.)

8

INTRODUCTION

Although Maryland was founded in 1634, it took nearly 100 years for settlement to finally reach this portion of the state. In 1725, what is now Washington County was considered the true frontier of Maryland and was inhabited mostly by Indians, trappers, and traders. But as large numbers of Germans sought freedom in America and arrived in Pennsylvania, prices rose, and land became scarce, forcing newly arriving Germans to seek land elsewhere. Many passed through Maryland on their way to acquire land in Virginia.

Hoping to get these Germans to settle in Maryland, Lord Baltimore offered them a special incentive in 1732. He promised each family 200 acres of land at no charge if, within three years, they would develop a working farm with an orchard of 100 trees. After three years, they would just be required to pay a yearly ground rent—a real estate tax. This special offering of land by Lord Baltimore initiated the development of western Maryland.

Boonsboro was founded in 1792 by two brothers from Berks County, Pennsylvania, George and William Boone. The Boone brothers were members of the famous clan of explorers. Their grandfather George was an uncle to Daniel Boone, the famous frontiersman, making them first cousins once removed to Daniel. Their mother, Sara Lincoln Boone, was the sister of John Lincoln, the great-grandfather of Abraham Lincoln.

Several Boone families had moved to this area of Maryland by 1767. Records show that Samuel Boone, a gunsmith, had a gun shop at or near Fredericktown about that time. In 1776, he manufactured gunlocks for the Continental Army during the Revolutionary War.

In 1791, after having lived in the area for about 15 years, William Boone, a farmer, purchased an additional 140 acres of land from Valentine Nicodemus. This tract of land, called Fellowship, was adjacent to his 100-acre farm and lay along the wagon road connecting Fredericktown to Hagerstown. With the help of his brother George, William began to plan a town.

Using the secondary wagon road, which turned toward Sharpsburg, as the center, or town square, the Boones laid out a total of 44 half-acre lots, with 22 along each side of the main wagon road. This major road became Main Street. Although the Boones called their new town Boone's Berry, the first map to show the town gives it the name Margaretsville in honor of George's wife. By 1808, the new town had officially become Boones Borough, later shortened to Boonsboro.

Being situated along an important road, Boonsboro grew quickly and soon became a busy little village. One of the earliest references to Boonsboro was in 1796 when Francis Baily, an Englishman, traveled the wagon road passing through the town.

Baily wrote, "We had not traveled far into the valley when we come to a little place called Boone's-town where we were glad to rest ourselves and horses after the fatigues of so rough a road. Boone's-town is 18 miles from Fredericktown: it has not been settled above three or four years. We met with a very good tavern and excellent accommodations."

In 1801, the post office was established in Boonsboro, and Peter Conn, proprietor of the newly constructed Eagle Hotel, became the first postmaster. The town continued to grow; tax records show that it contained 24 houses in 1803. After the last stretch of all-weather turnpike from Baltimore to Boonsboro was completed in 1810, the town became an important trade center. To serve the increased traffic along the turnpike, Boonsboro had several hotels and taverns and a host of merchants and craftsmen.

Census records show that, by 1820, the town's population had grown considerably. There were 428 inhabitants: 395 whites, 7 free blacks, and 26 slaves. Through the years, some of the town's more notable craftsmen included Peter Baker and John Welty, coverlet makers; Daniel Christian and John Peterbenner, shoemakers; Leonard Weast and Peter Heck, carpet weavers; Abijah Smith and John C. Brining, cabinetmakers; Charles Gabe and Frank Storm, tinners; Daniel Boone and Ephraim Davis, hatmakers; Aaron Pry, Henry Nyman, and Jonathan Gelwicks, tailors; and John Stonesifer and his son Christian, gunsmiths.

The town also had many merchants and tavern keepers. A few of the merchants were George Troutman, Moses Bomberger, Samuel Mumma, and a Mrs. Short. Some of Boonsboro's early innkeepers were Matthew Collins, Peter Conn, Captain Brookhart, and James Chambers.

In 1823, when the last section of turnpike road from Boonsboro to Hagerstown was finally hard-surfaced, the Boonsboro Turnpike Company had used a new technique called macadam. It was the first use of the new road-building process in the United States.

However, Boonsboro's greatest claim to fame is probably that its early citizens built the first monument to honor George Washington. Early on the morning of July 4, 1827, a large group of Boonsboro citizens, having assembled at the town square, began a march to the top of South Mountain. Led by Anthony Beltzer and George I. Hardy, both of whom had served under General Washington in the Revolutionary War, the villagers proceeded to the area known as the Blue Rocks. The chosen location overlooked the Old Braddock Road, later named the National Pike, which was traveled by such famous men as George Washington, Henry Clay, and Abraham Lincoln. Under the direction of Isaac C. Lutz, one of the most skilled stonewall builders of his time, the villagers constructed a crock-shaped monument of carefully hewn stone that was approximately 24 feet in diameter and 15 feet high. Upon completion of their labors, they read the Declaration of Independence and fired several salutes of musketry from the top of the monument.

Eventually, the ravages of time, along with some help from vandals, caused the monument to collapse. During the Civil War, it lay in ruins. Union soldiers used it as a signal station. Finally, the Boonsboro Odd Fellows organization started a movement to restore the monument. The local population supported the project, and steps were taken to raise the necessary funds. Madeleine Dahlgren, the widow of Adm. John Dahlgren, who had a summer residence on South Mountain, was instrumental in orchestrating the restoration. Nearly 3,000 people attended the rededication in August 1882.

Some 20 years later, either because of faulty reconstruction or a stroke of lightning—or, as some have said, a stick of dynamite—a rent appeared in the structure, causing it, once again, to collapse. The citizens of Boonsboro and the vicinity again rallied to save the monument, and finally, through the concerted efforts of many organizations and individuals, the Civilian Conservation Corps (CCC) began to restore the edifice to its present condition in 1934. In July 1936, hundreds of people assembled for a rededication program once again.

The Town of Boonsboro was incorporated in 1831. In the town's first election, Jonathan Shafer was chosen burgess and Capt. Lewis Fletcher assistant burgess. During this period, Boonsboro's largest mercantile establishment conducted more than $90,000 a year in retail business—a tremendous amount for that time.

In September 1862, during the Confederates' first foray into the North, the rebel army crossed South Mountain and occupied Boonsboro, encamping on the farm of John Murdock. It was at Boonsboro that Gen. Thomas J. "Stonewall" Jackson narrowly escaped capture by a detachment of Union cavalry. During that same episode, Confederate colonel S. Bassett French was interrupted during a meal at the United States Hotel in Boonsboro and was forced to hide in the coal cellar.

Afterward, Colonel French joked that he had indeed escaped capture, but those "damn Yankees" had gotten his apple pie.

The Battles of South Mountain and Antietam were fought on September 14 and 17, 1862, respectively. After the horrible slaughter had ended, Boonsboro was overflowing with the wounded. All the churches and public buildings were turned into makeshift hospitals. Confederate surgeon John Mutius Gaines of Virginia had been captured and assigned to attend the Confederate wounded in Boonsboro. While carrying out his duties, he met the daughter of the local physician Otho J. Smith. After the war ended, Dr. Gaines returned to marry Smith's daughter and practiced medicine in Boonsboro for almost 30 years.

The Heck family of Boonsboro provides an excellent example of how the Civil War often divided kinfolk. One son, Jacob, joined the Confederacy, while his brother John chose the Union army. The brothers fought on opposite sides at both South Mountain and Antietam. Between battles, they actually ate a meal together while visiting their mother and sister in Boonsboro.

In the late 19th century, Boonsboro was chosen as the setting for David Belasco's famous play about the American Civil War. The play, *The Heart of Maryland*, depicted the town as being typically Southern. About 1915, the play became a successful motion picture.

During the 20th century, agriculture and fruit growing were the principal means of livelihood for Boonsboro and its environs. Local strawberries, raspberries, and peaches were considered some of the best grown anywhere. In 1939, more than 17,000 bushels of raspberries were shipped from the area. Also, of course, Boonsboro's "Hearts of Gold" cantaloupes had no equal.

For 220 years, Boonsboro has been a progressive community. As one historian wrote, "Boonsboro was not only the first in its construction of the Washington Monument. Outside of Hagerstown, Boonsboro was the first town in Washington County to have a high school, a free library, a water system, electric lights, a newspaper, a community mausoleum, and a memorial to the soldiers killed in World War I."

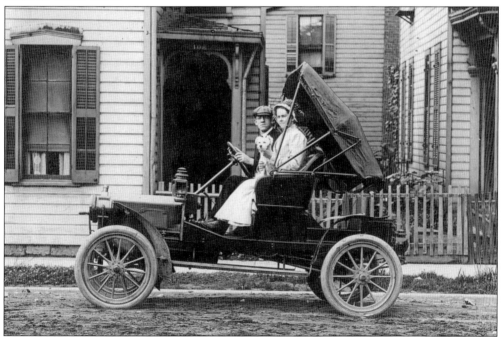

A man holds a right-side steering wheel while a woman holds a small white dog following the trio's journey from Ohio to Boonsboro in this early-1900s automobile. Shown with their "convertible" top pushed back, the unidentified travelers were visiting relatives in the Boonsboro area. (Courtesy of the Boonsborough Museum of History.)

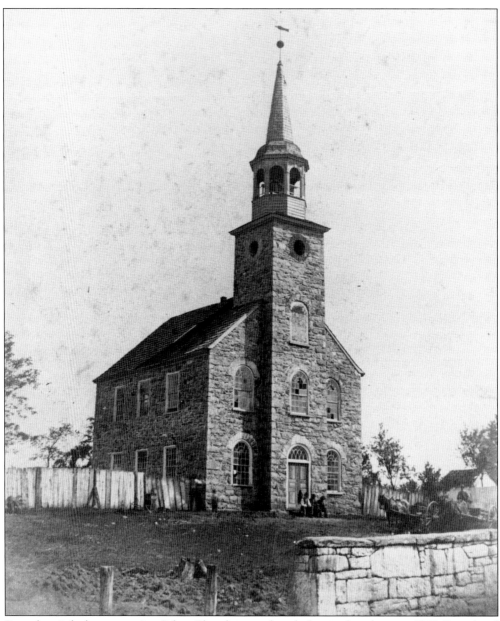

Boonsboro's dual-congregation Salem Church is seen here before its demolition in 1870. Completed in 1806, Salem Church served Lutheran and Reformed congregations until 1859. In its early days, with the exception of the Zion Reformed Church in Hagerstown, the Boonsboro building was considered the finest stone church in western Maryland. In 1870, an independent Trinity Reformed Church was constructed on the site of the former Salem Church at 33 Potomac Street. That same year, a separate Trinity Lutheran Church was built at 64 South Main Street. Today, members of both Boonsboro congregations worship in church buildings with cornerstones that were put in place in the same year, 1870. Known as Trinity Reformed United Church of Christ and Trinity Evangelical Lutheran Church, the churches claim a combined history dating back to 1750, when their services were held in a log building a half mile northeast of town. (Courtesy of the Boonsborough Museum of History.)

One

THE TOWN

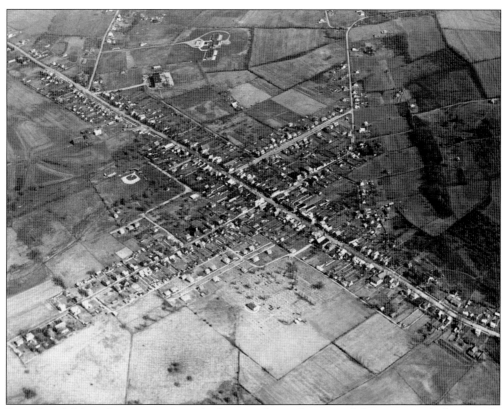

Boonsboro's Main Street runs from the lower right to the upper left in an aerial photograph, taken about 1950 by Gene Virts of the Fairchild Aircraft Company in Hagerstown. Potomac Street—formerly Church Street—enters at the lower left and becomes St. Paul Street as it crosses Main Street at the town square. The baseball diamond in Shafer Park is left of center, just below the former Boonsboro High School building and a trio of newer school buildings. (Courtesy of the Washington County Free Library.)

Dated December 15, 1808, Henry Neiman's lot No. 12 real estate tax receipt for the years 1805 through 1808 is signed by Boonsboro cofounder George Boone. Boone also writes his town's name as "Boones Berry," one of several variations of the town's name before Boonsboro was made permanent. Called Margaretsville in honor of George Boone's wife, the town was officially founded when George and his brother William Boone sold the town's first lot in 1792. The brothers were cousins of American frontiersman Daniel Boone. (Courtesy of the Boonsborough Museum of History.)

BOONSBORO, DISTRICT No. 6.

NAME.	No. of Acres.	POST-OFFICE.	OCCUPATION.	NATIVITY.	Date of Settlement.
Brown, James	17	Boonsboro	Surveyor and Convey'r	Hillsboro Co., N.H.	1826
Bowman, John E.	...	"	Potter	Washington Co., Md	1841
Hoffman, Geo. W.	...	"	Druggist	Jefferson Co. Va	1854
Henry, Pr. R. Saunders	...	"	Prin. High School	Harford Co., Md.	1875
Huffer, A. C.	400	"	Farmer	Washing'n Co., Md.	1836
Kennedy, George S.	997	"	"	Frederick Co., Md.	1821
Murdock, John	425	"	Justice of the Peace	Ireland	1844
Nicodemus, J. L.	307	"	Miller	Washing'n Co., Md.	1828
Newcomer, D. H.	400	Benevola	State Senator	" "	1815
Rohrer, Samuel	14	Boonsboro	Teacher	" "	1819
Smith, George F.	...	"	Pro. Hotel	Clark Co., Va.	1829
Stonesifer, Chas. M.	...	"	Merchant	Washing'n Co., Md.	1858
Schlosser, M. E.	246	"	Farmer	Loudon Co., Va.	1845
Stouffer, D. F.	75	Benevola	Auctioner	Franklin Co., Pa.	1845
Smith, Wm. F.	34	Boonsboro	Farmer	Washing'n Co, Md.	1820
Smith, Otho B.	258	"	"	" "	1838
Schlosser, E.	125	"	"	" "	1838

This roster of 17 Boonsboro community leaders appears in *An Illustrated Atlas of Washington County, Maryland*, a large community reference book printed in 1877. Representing Boonsboro election district No. 6 in the impressive list of *Atlas* patrons are several businessmen and farmers, a high school principal, and a state senator, all from the town of Boonsboro and its environs. (Courtesy of the Washington County Free Library.)

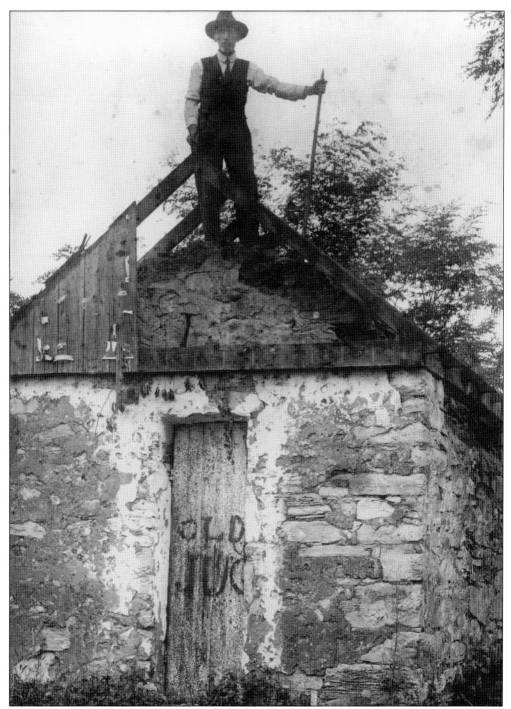

A man stands on top of the Boonsboro jail during its demolition about 1915. Known as the "Old Jug," the stone structure was built in 1835 by John Fague for a reported cost of $45. The old jail was located just west of Trinity Reformed Church and just north of Church Street. (Photograph by C.D. Young; courtesy of the Boonsborough Museum of History.)

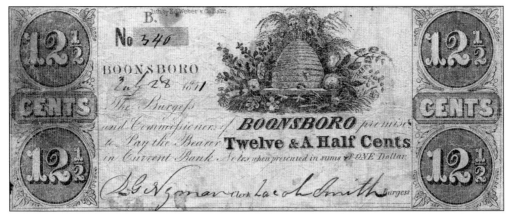

Issued by the town government after an economic depression made specie (coined money) scarce, this July 28, 1841, piece of fractional script currency explains that "the Burgess and Commissioners of Boonsboro promise to Pay the Bearer Twelve & A Half Cents in Current Bank Notes, when presented in sums of ONE Dollar (eight scripts)." Considered extremely rare, script No. 340 is signed by Town Clerk D.G. Nyman and by Burgess Jacob Smith. Smith served as burgess—or mayor—of Boonsboro from 1841 to 1843 and from 1856 to 1857. (Courtesy of the Boonsborough Museum of History.)

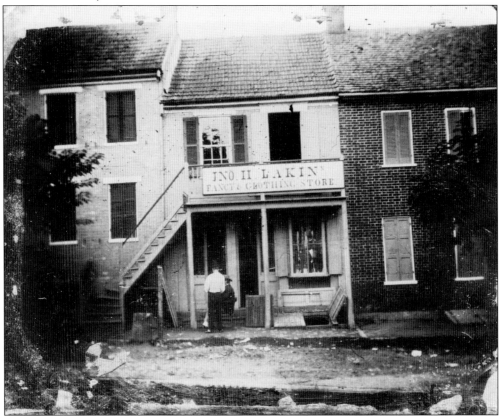

The 1870s sign on this building at 20 North Main Street advertises John H. Lakin's Fancy & Clothing Store. Stairs appear to lead to the second-floor entrance to Lakin's tailor shop. (Courtesy of the Boonsborough Museum of History.)

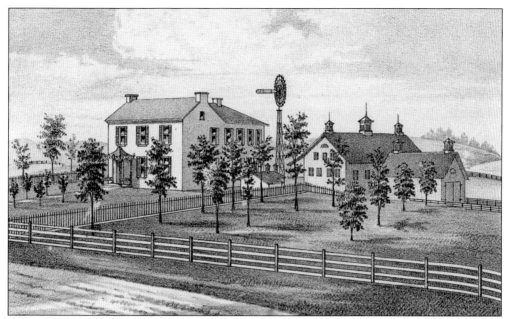

This artist's depiction of the Otho B. Smith residence appears in *An Illustrated Atlas of Washington County, Maryland*. Complete with house, barn, windmill, and outbuildings, the Smith residence was located on the west side of North Main Street where the Boonsboro American Legion building stands today. (Courtesy of the Washington County Free Library.)

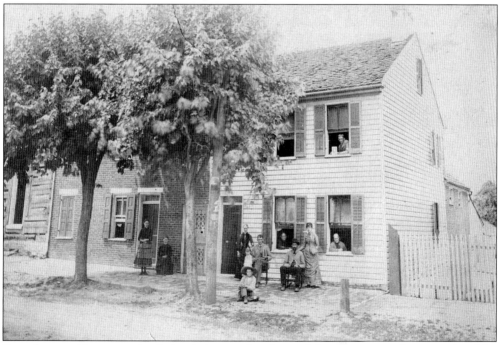

Boonsboro residents pose in their windows and in front of their houses on the west side of the 100 block of North Main Street in the late 1800s. A fresh water spring has run beneath the house on the right for many years. An early log structure is seen at the far left. (Photograph from the John H. Bast estate; courtesy of the Boonsborough Museum of History.)

NOTICE
TO ALL WHOM IT MAY CONCERN.
ON AND AFTER
Novemb'r 1, 1864,
THE FOLLOWING
RATES OF TOLLS
WILL BE CHARGED ON THE
BALTIMORE & FREDERICK & BOONSBORO
TURNPIKE ROADS
FOR A TEN MILE GATE.

						CENTS
For every score of Sheep or Hogs,					-	20
For " " Cattle,			-	-	- -	40
For every Horse & Rider, or led Horse,						10
For every Wagon with 1 Horse, Narrow Wheels,						20
"	"	"	2	"	"	40
"	"	"	3	"	"	60
"	"	"	4	"	"	80
"	"	"	5	"	"	1.00
"	"	"	6	"	"	1.20
"	"	Coach, with four Horses,				60

One-half of the above Rates for a Broad-Tread Wagon. All Wagons whose wheels does not measure full four inches will be charged as Narrow-Tread from the above date.

By order of the Presidents, Managers and Companies of the above mentioned Roads.

October 8, 1864.

Effective November 1, 1864, the Boonsboro Turnpike Road 10-mile tolls ranged from 20¢ for 20 sheep or hogs to $1.20 for a wagon with six horses and narrow wheels. The undated notice at right indicates much lower earlier rates, ranging from 12 ½¢ to 75¢. In addition, the earlier 10-mile toll of 37 ½¢ for a coach and four horses jumped to 60¢ in 1864. However, wagons with four-inch "broad-tread" wheels received half-off rates under both earlier and later rate structures. Funeral charge wording was eliminated from the 1864 notice. (Left, courtesy of the Washington County Free Library; right, courtesy of the Boonsborough Museum of History.)

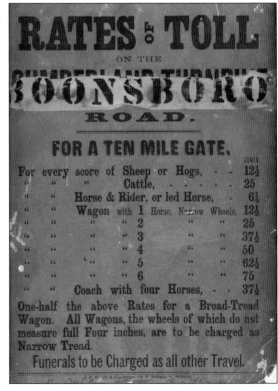

RATES OF TOLL
ON THE
BOONSBORO
ROAD.

FOR A TEN MILE GATE.

						CENTS
For every score of Sheep or Hogs,					- -	12½
"	"	"	Cattle,	-	- - - -	25
"	"	Horse & Rider, or led Horse,			-	6¼
"	"	Wagon with 1 Horse, Narrow Wheels,				12½
"	"	"	"	2	" "	25
"	"	"	"	3	" "	37½
"	"	"	"	4	" "	50
"	"	"	"	5	" "	62½
"	"	"	"	6	" "	75
"	"	Coach with four Horses,			- -	37½

One-half the above Rates for a Broad-Tread Wagon. All Wagons, the wheels of which do not measure full Four inches, are to be charged as Narrow Tread.

Funerals to be Charged as all other Travel.

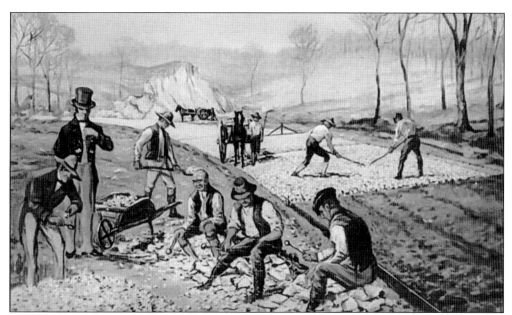

This painting by 20th-century artist Carl Rakeman shows a group of workers installing the first macadam road surface in the United States along the Boonsborough Turnpike Road between Boonsboro and Hagerstown in 1823. The turnpike road is the National Road or Alternate US Route 40 today. The US Department of Transportation explains the 1823 Boonsboro-to-Hagerstown macadam road project as follows: "By 1822 this section was the last unimproved gap in the great road leading from Baltimore on the Chesapeake Bay to Wheeling on the Ohio River. Construction specifications for the turnpike road incorporated those set forth by John Loudoun McAdam of Scotland. After side ditches were dug, large rocks were picked and raked, then were broken 'so as not to exceed 6 ounces in weight or to pass a two-inch ring.' Compacting work for each of the three layers was quickened using a cast-iron roller instead of allowing for compacting under traffic." (Courtesy of the Federal Highway Administration US Department of Transportation.)

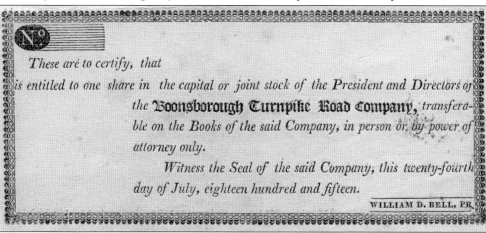

Dated July 24, 1815, this Boonsborough Turnpike Road Company single-share stock certificate awaits a number, a buyer's name, the company seal, and the signature of William D. Bell, president of the Boonsborough Turnpike Road Company. The Washington County town had undergone a spurt of growth and prosperity five years earlier when an all-weather turnpike road was completed from Baltimore to Boonsboro. (Courtesy of the Boonsborough Museum of History.)

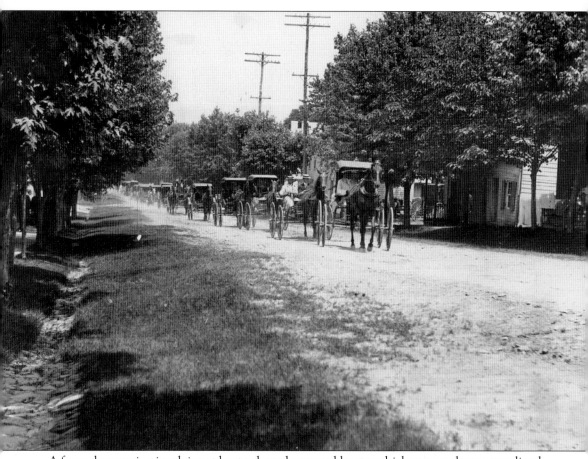

A funeral procession involving at least a dozen horse-and-buggy vehicles moves down a tree-lined Boonsboro street in the early 1900s. The street has concrete sidewalks, a stone-lined drainage ditch, and utility poles. (Courtesy of the Boonsborough Museum of History.)

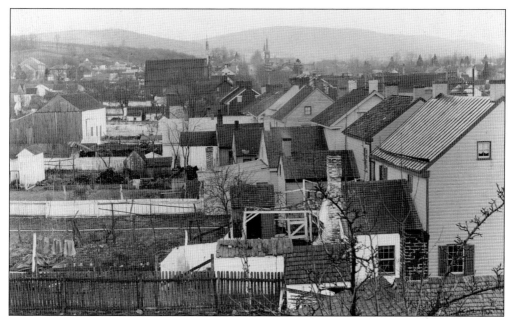

Fences, outbuildings, and building additions are seen in this c. 1915 view of the backs and backyards of houses on the east side of North Main Street. The South Mountain range is in the distance beyond the steeples of the Trinity Lutheran and Mount Nebo Churches. Boonsboro photographer C.D. Young captured this scene from atop his Main Street residence. (Courtesy of the Boonsborough Museum of History.)

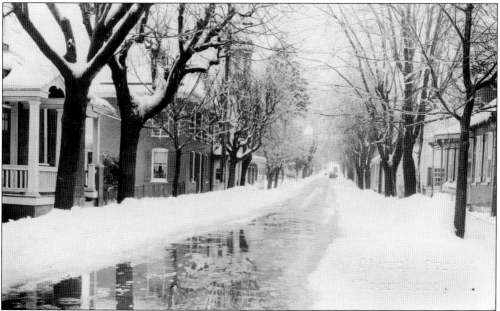

Ice clings to tree limbs, snow banks line sidewalks, and melting precipitation forms a large puddle following a winter storm in this C.D. Young image, captured about 1915. Embossed typewriter letters in the right foreground confirm that this slippery thoroughfare is Church Street. The view seems to be toward the west near the old public school. (Courtesy of the Boonsborough Museum of History.)

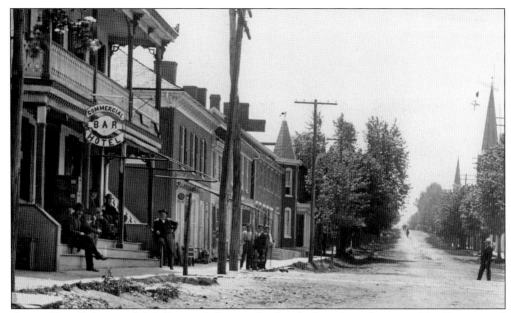

A man (far right) crosses Main Street while several others look on from the steps of the Commercial Hotel, located on the northeast corner of St. Paul and Main Streets in the center of Boonsboro, about 1915. The steeples of Trinity Lutheran and Mount Nebo Churches stand above the trees on the far right. (Photograph by C.D. Young; courtesy of the Boonsborough Museum of History.)

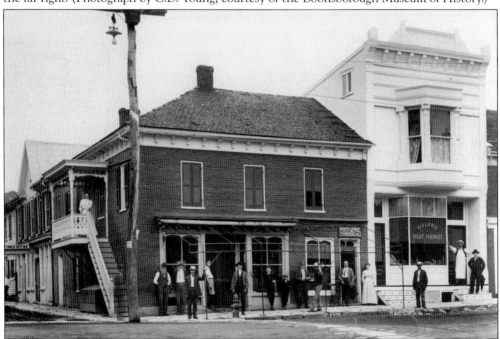

An early electric streetlight hangs above people gathered at the center of Boonsboro on the southeast corner of Main and St. Paul Streets about 1915. The large brick building in the center houses the town post office. Galor's Meat Market is located in the white cast-iron covered building on the right. The office of the *Boonsboro Times* newspaper is at the far left. (Photograph by C.D. Young; courtesy of the Boonsborough Museum of History.)

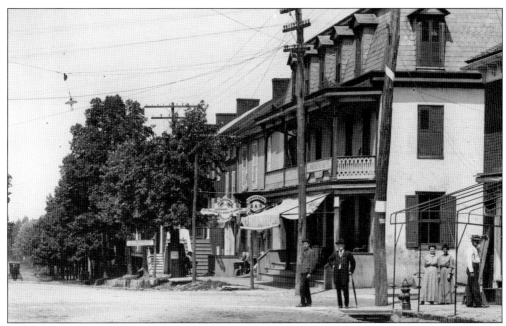

A horse and buggy (far left) heads south on Main Street as people gather in the center of town at St. Paul Street. Behind the man leaning on his umbrella are signs for the following: Commercial Hotel and Bar, H.C. Dagenhart Confectionery and Groceries, and Henry Adams Roofing, Spouting, Plumbing, Tinning, Hardware, and Hot Air Furnace Work. (Photograph by Cadville D. Young; courtesy of the Boonsborough Museum of History.)

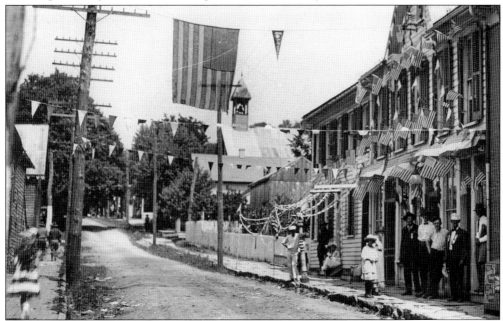

More than 30 American flags decorate the front of the St. Paul Street building during a day of patriotic Boonsboro celebrations about 1918. The bell tower of the First Christian Church (Disciples of Christ) is to the right of the large flag hanging above the street. (Photograph by C.D. Young; courtesy of the Boonsborough Museum of History.)

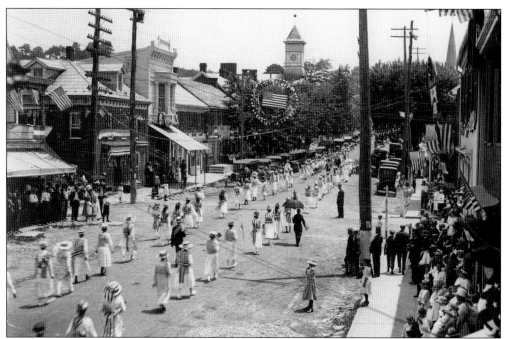

Main Street marchers parade south through Boonsboro's town square beneath a "Welcome Home" flag. The Independent Order of Odd Fellows clock tower building is behind the flag. The Trinity Lutheran Church steeple is in the upper-right corner. (Photograph by C.D. Young; courtesy of the Boonsborough Museum of History.)

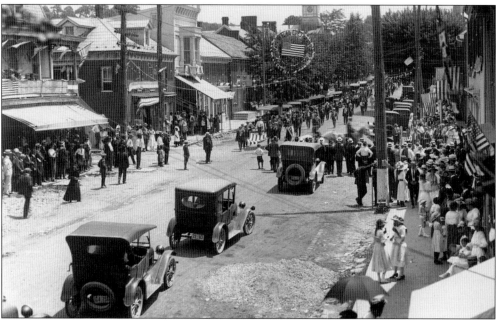

Automobiles line up, and spectators crowd the sidewalks as marchers parade north on South Main Street and turn west on Church Street beneath a 48-star American flag in the center of the large "Welcome Home" celebration medallion. The patriotic event may be marking the end of World War I in 1918. (Photograph by C.D. Young; courtesy of the Boonsborough Museum of History.)

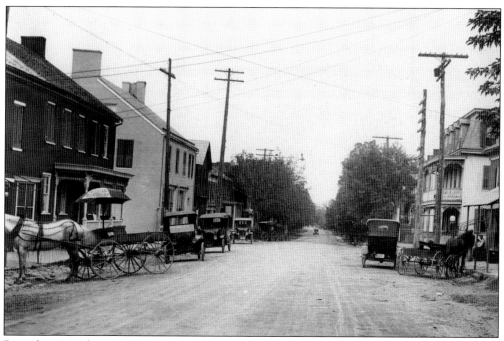

Boonsboro's 19th-century United States Hotel was originally located where the dark building on the left is, and the 19th-century Eagle Hotel was where the light-colored building on the far right is. In this early-20th-century image, the umbrella on the left advertises Atlas Prepared Paint, made by George D. Wetherhill & Co. in Philadelphia. (Courtesy of the Boonsborough Museum of History.)

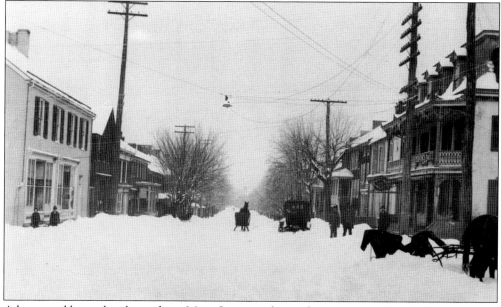

A horse and buggy heads north on Main Street as electric lines swing overhead. Also, a truck is up to its axles in snow in front of the Mountain Glen Hotel in this C.D. Young photograph from 1915. St. Paul Street enters Main Street on the far right, and Potomac Street hits Main Street on the far left at the town square. (Courtesy of the Boonsborough Museum of History.)

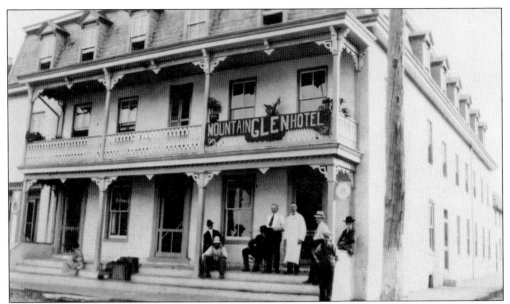

Folks gather on the front steps of Hezekiah Snavely's Mountain Glen Hotel on the northeast corner of Main and St. Paul Streets in the center of Boonsboro in 1922. Recorded as one of five existing Boonsboro buildings in 1796, the Mountain Glen Hotel was known as the Eagle Hotel in 1877 and the Commercial Hotel in 1897. (Photograph by Fred Wilder Cross; courtesy of the Boonsborough Museum of History.)

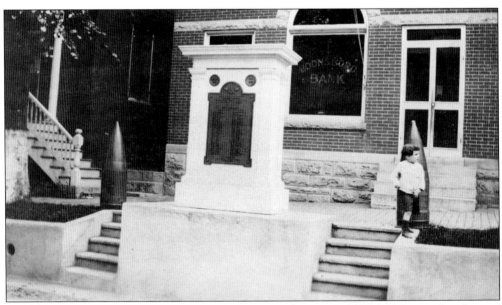

A child stands in front of a large cannon shell at Boonsboro's World War I Memorial in front of the Boonsboro Bank in 1919. Located at 19 North Main Street, the former bank building, built in 1905, served as home to the Boonsboro Free Library from 1974 to 2008, at which time it moved into a new 10,000-square-foot building at 401 Potomac Street, which is capable of holding more than 40,000 books. (Photograph by Fred Wilder Cross; courtesy of the Boonsborough Museum of History.)

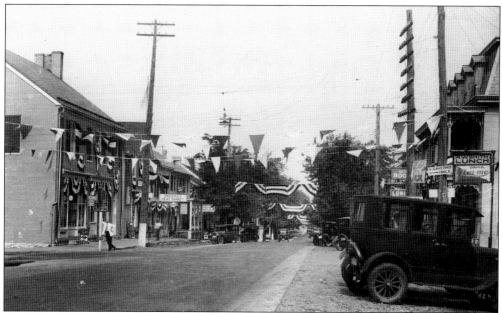

A man in a white coat leans against a Main Street road sign about 1915 in the center of Boonsboro as patriotic Decoration Day banners wave. Signs advertise groceries, a meat market, underground caverns, luncheon establishments, and the Hotel Boone (formerly the Mountain Glen, Commercial, and Eagle Hotels). Sharpsburg is six miles west, and Pleasant Walk is five miles east. (Photograph by C.D. Young; courtesy of the Boonsborough Museum of History.)

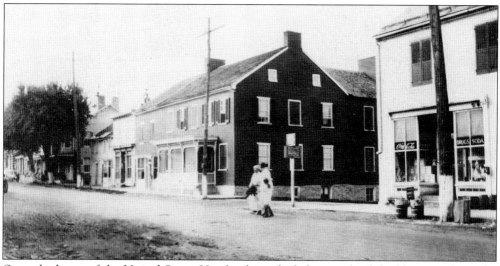

Once the home of the United States Hotel, a large dual-chimney brick building stands on the southwest corner of Main and Potomac Streets as two women cross Boonsboro's town square intersection in this 1922 photograph by Fred Wilder Cross, Boston-based Civil War historian. Cross wrote detailed scholarly documents centered on his many research visits to the Boonsboro area. (Courtesy of the Boonsborough Museum of History.)

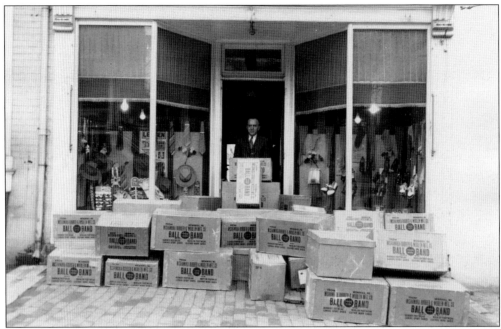

"Happy" Huffer looks over a newly arrived 30-box shipment stacked on the brick sidewalk in front of his Main Street shoe store in the 1940s. Ball Band shoes were made by the Mishawaka Rubber and Woolen Manufacturing Company in Indiana. In addition to shoes and socks, Huffer's store offered men's shirts, ties, and hats. (Courtesy of the Boonsborough Museum of History.)

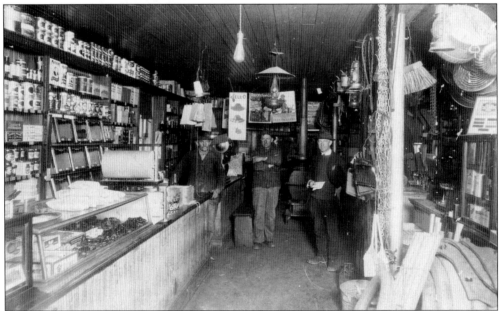

Surrounded by early-1900s items in Boonsboro's Warrenfeltz Store are, from left to right, Martin, Bela, and Frank Warrenfeltz. Behind them are advertising posters for Ferry's Seeds and Jell-O gelatin and a potbelly stove. Canned goods line the walls while a coal oil lamp and an electric light hang side by side on the ceiling of the popular general store. (Courtesy of the Boonsborough Museum of History.)

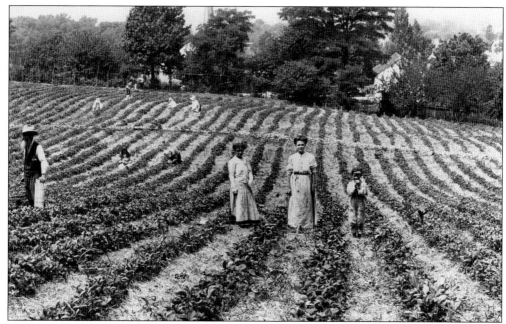

With one hand resting on a stack of strawberry containers, William Stem (left) oversees workers in his large strawberry patch on Short Hill Mountain along the southeastern edge of Boonsboro about 1910. On the horizon is the steeple of Boonsboro's Mount Nebo Church on South Main Street. (Photograph by Cadville D. Young; courtesy of the Boonsborough Museum of History.)

H.C. Dagenhart stands with his wife, daughter, and son on the porch of the family's confectionery and groceries store on the east side of Main Street about 1915. Today, the Dagenhart building houses a fast food restaurant. (Courtesy of the Boonsborough Museum of History.)

The same uniformed deliveryman stands at both ends of his truck in this bit of 1930s trick photography by Boonsboro photographer Gerald D. Bast. Behind the vehicle are the gasoline pumps at the Mrs. S.E. Wolf Groceries and Ice Cream store on North Main Street in Boonsboro. (Courtesy of the Boonsborough Museum of History.)

BRANCHES ESTABLISHED.
1901-1902

TOWN	IN CHARGE OF	NO. BOOKS	CIRCU- LATION
Beaver Creek	D. J. Witmer	136	408
Boonsboro	H. S. Bomberger	296	1,094
Benevola	H. S. Lovell	215	339
Bakersville	R. H. Petrie	188	385
Breathedsville	J. E. Keller	100	195
Brownsville	G. T. Brown	149	343
Cavetown	A. H. Beamer	165	414
Chewsville	B. F. Ridenour	100	170
Clearspring	J. E. Anderson	280	771
Fairplay	M. L. Santman	202	578
Halfway	N. E. Morin	141	205
Hancock	J. T. Mason	258	1,265
Keedysville	C. Motter	215	368
Leitersburg	J. Ground	141	455
Maugansville	D. E. Downin	138	435
Rohrersville	H. C. Hightman	179	378
St. James' School	H. W. Keating	127	347
Sandy Hook	V. I. Shrewbridge	194	322
Sharpsburg	V. R. Munma	194	551
Smithsburg	T. Simmers	211	712
Tilghmanton	J. Bloom	136	210
Trego	S. O. Buck	89	193
Williamsport	J. L. Lemen	177	516
R. R. Y. M. C. A.	J. Grubb	100	100
		4,131	10,654

1902-1903

Antietam	C. Drenner	50	50
Byron's Tannery	A. G. Hoffman	50	50
Cearfoss	V. M. Cunningham	100	196
Clevelandsville	L. M. Moser	50	50
Downsville	G. Downs	107	210
Eakle's Mills	S. O. Eakle	50	50
Gapland	N. O. Mullendore	114	140
Locust Grove	J. S. Stine	109	140
Mapleville	P. A. Cost	96	125
Mt. View Creamery	P. O. Philo	84	160
Ringgold	G. H. Dickel	87	150
Sandy Hook, No. 2	Mrs. Wolfsberger	50	50
Sharpsburg, No. 2	W. J. Highbarger	89	171
Smoketown	J. W. Renner	45	45
Weverton	A. B. Bingham	50	50
		1,131	1,637

12

A 1903 page from the second annual report of the Boonsboro Free Library shows its position among the 39 branch libraries established in 1901 and 1902 by the Washington County Free Library in Hagerstown. Launched in 1900 by Josiah Pierce Jr., the son-in-law of Civil War admiral John A. Dahlgren, the Boonsboro branch opened in 1901 with 50 books available in a wooden box at Harvey S. Bomberger's Main Street store. (Courtesy of the Washington County Free Library.)

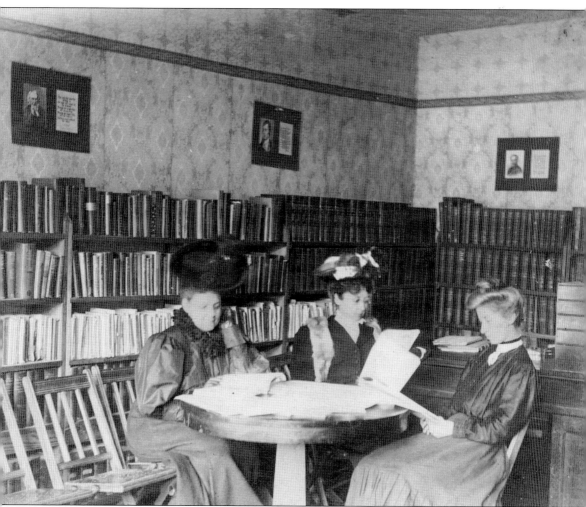

Three women look over books and documents in the 1907 Boonsboro Free Library Reading Room at 9 South Main Street. A branch of the Washington County Free Library in Hagerstown, the Boonsboro library later moved to the current town hall building at 21 North Main Street. From 1948 to 1974, the library was located at 11 St. Paul Street in a 1912 building that had previously served as a town municipal building and fire hall. (Courtesy of the Washington County Free Library.)

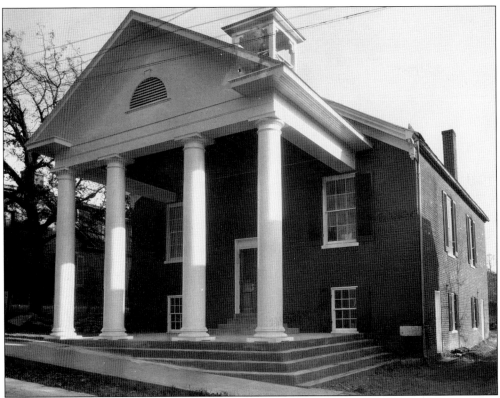

Boonsboro's First Christian Church (Disciples of Christ) building is seen below in an 1898 photograph from Hiedewohl's Studio in Hagerstown and above after four large white columns and a roof-covered entrance were added to the front of the historic building. The structure's cornerstone, windows, shutters, and bell tower remained in their positions after the large roof-covered entrance was added. Located at 12 St. Paul Street near the center of Boonsboro, the building served as a hospital after the Battles of Antietam and South Mountain. (Courtesy of the Washington County Free Library.)

Standing on a new concrete sidewalk about 1900, a young woman is dwarfed by the north wall of Trinity Evangelical Lutheran Church at 64 South Main Street. The town's large local cemetery is in the distance beyond the end of the sidewalk and gravel access road. The Lutheran church building was completed and dedicated in 1871. (Courtesy of the Boonsborough Museum of History.)

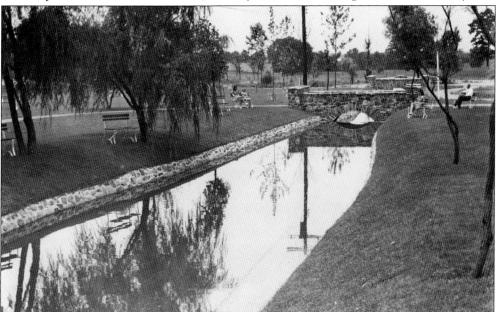

Trees, benches, and a stone bridge are reflected on the surface of the Boonsboro town run as it makes its way through Shafer Memorial Park in September 1942. The stream's stone bridges and banks were part of a Works Progress Administration (WPA) park construction project in the 1930s. In the early 1800s, the park was the site of a large tannery operation owned by Jonathan Shafer, whose descendants donated the land for the town park in the 1900s. Today, Shafer Park is the scene of many popular community events, including the Fourth of July fireworks festival and Boonsboro Historical Society's Boonesborough Days festival in September. (Photograph by Gerald D. Bast; courtesy of the Boonsborough Museum of History.)

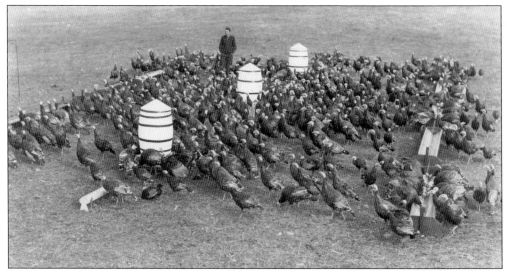

Charles Bast surveys a flock of turkeys as the birds mill around their water stations and feeding troughs. Bast raised turkeys on the east side of Boonsboro in the 1930s and 1940s. (Courtesy of the Boonsborough Museum of History.)

This patriotic home, known as "Lilacs on Rose Hill," was used as a "Southern mansion" in the 1915, 1921, and 1927 silent movie productions of the world-famous 1895 play *The Heart of Maryland*. Its playwright, David Belasco, was a frequent Boonsboro visitor. *The Heart of Maryland* is considered the first American play to be successful in England. Today, the Southern mansion is part of Reeders Memorial Home. (Photograph by C.D. Young; courtesy of the Boonsborough Museum of History.)

Part of Reeders Memorial Home today, the Southern mansion previously used in *The Heart of Maryland* is identified by a mid-1900s sign above its entrance as Milford Convalescent Home. (Courtesy of the Washington County Free Library.)

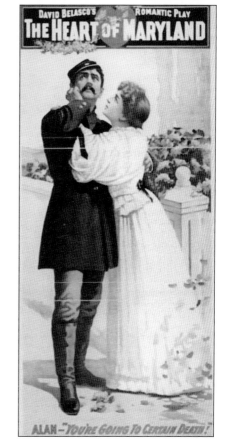

On this poster for *The Heart of Maryland*, actress Leslie Carter, who plays Maryland Calvert, exclaims, "Alan–You're going to certain death!" to Maurice Barrymore's Col. Alan Kendrick. With its Civil War theme, the romantic play and its subsequent silent film versions all take place in the "typical Southern town" of Boonsboro. After a 240-performance run in New York City, the play toured the United States for several years. The costume drama's silent film versions were made in 1915, 1921, and 1927. (Courtesy of the Library of Congress.)

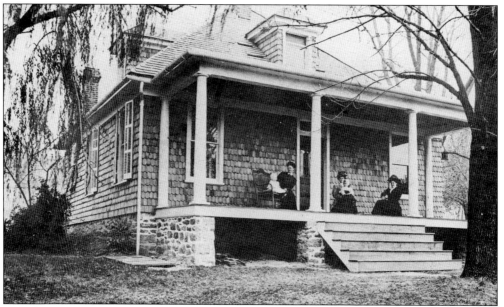

Seated on the front porch of Agnes Murphy's Boonsboro residence, three well-dressed women hold two young children in a 1908 postcard. With a 1¢ Benjamin Franklin postage stamp postmarked December 24 in Boonsboro, the postcard is addressed to the wife of Boonsboro tinsmith Frank M. Storm. Its handwritten note says, "Christmas Greetings from 'The Shanty'–1908." (Courtesy of the Boonsborough Museum of History.)

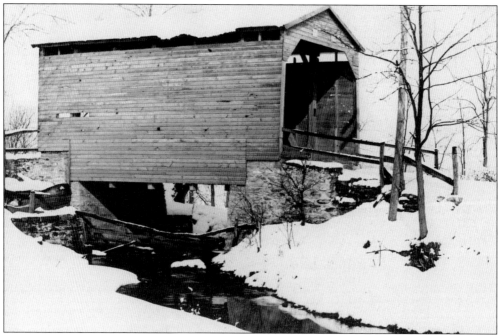

A covered bridge carried Church Street over a snow-bound creek about four blocks west of Boonsboro's town square. Legend has it that a relative of Gen. Robert E. Lee was forced to take refuge under this bridge after his horse stumbled during Civil War maneuvers in the area. (Courtesy of the Boonsborough Museum of History.)

Civil War veteran William Stem sits in his front yard rocking chair accompanied by his daughter, his granddaughter, and her doll about 1910. Stem maintained a large commercial strawberry patch operation at his Short Hill Mountain home on the southeastern edge of Boonsboro. (Photograph by C.D. Young; courtesy of the Boonsborough Museum of History.)

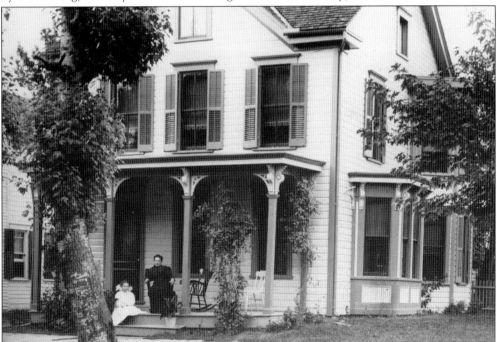

A girl in white and a woman in black sit on the front porch of the Brining House at 113 North Main Street about 1920. Originally the residence of Boonsboro cabinetmaker John Christian Brining and his family, the house became the Boonsborough Museum of History in 1974. This C.D. Young photograph was included in a special calendar produced in 1992 for the 200th anniversary of Boonsboro's founding. (Courtesy of the Washington County Free Library.)

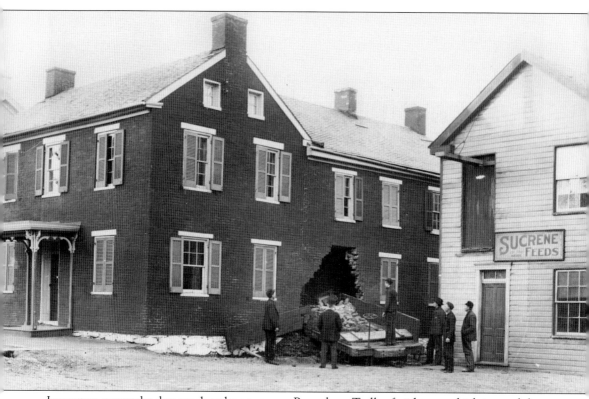

Inspectors survey the damage done by a runaway Boonsboro Trolley freight car, which jumped the tracks and smashed into Otto Neikerk's house at 208 North Main Street about 1910. Owned and operated by the Hagerstown-Frederick Electric Railway Company, the gondola car was carrying 15 tons of coal just north of Boonsboro when it broke loose from its motor car, ran down a steep grade, left the tracks, and traveled 40 feet before crashing through the north wall of Neikerk's house and coming close to hitting Neikerk's wife, who was in the dining room. According to the *Brunswick Herald* newspaper, the gondola car ran through the dining room and knocked out the wall between the dining room and the parlor. Almost every window glass was broken, the walls of the house were badly cracked, and dining room furniture was smashed into splinters, the newspaper reported. The gondola freight car passed within a few feet of Mrs. Neikerk and "bricks and mortar dislodged by the impact fell about her like hail," the *Herald* reported. (Courtesy of the Boonsborough Museum of History.)

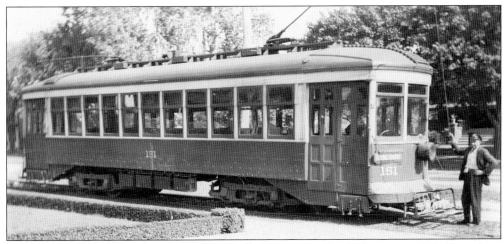

Trolley No. 151 prepares to leave Boonsboro for the last time in this 1938 image made by Boonsboro photographer Gerald D. Bast. Operated by the Hagerstown-Frederick Electric Railway Company, the Boonsboro Trolley had served its community for nearly 40 years. (Courtesy of the Boonsborough Museum of History.)

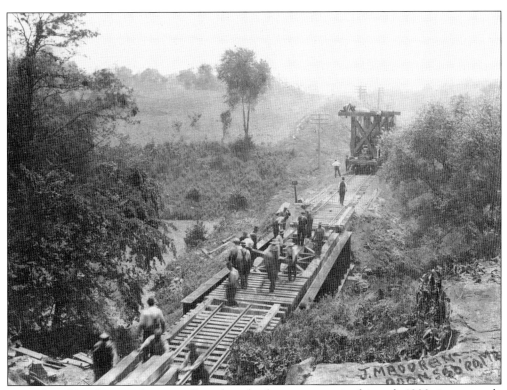

More than 20 railway workers install track and culvert supports in this early-1900s image, made by Boonsboro photographer James Maddran. Incorporated in 1899, the Hagerstown-Frederick Electric Railway Company operated the Boonsboro Trolley and several other lines from about 1902 until 1938. (Courtesy of the Boonsborough Museum of History.)

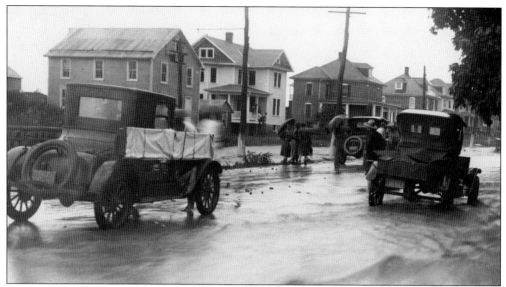

A barefoot man appears to be working on the front of the automobile on the left. With two other motorcars stopped, pedestrians survey a flooding situation on Main Street about 1915. Utility poles in the background appear to be carrying both electric and trolley power lines. (Courtesy of the Boonsborough Museum of History.)

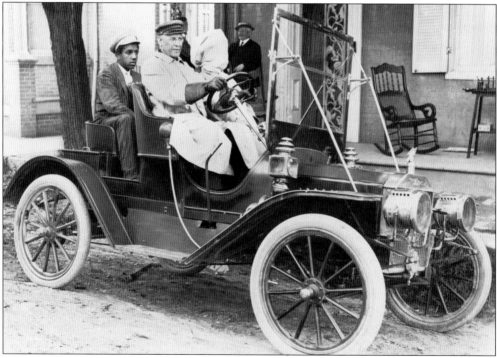

Dr. S.S. Davis of Boonsboro prepares to take to the road with passengers in about 1920. His front seat passenger appears to have her head wrapped in a see-through veil as protection from the elements. The large Ford automobile features a back seat, a right-side steering wheel, two sets of headlights, and what appears to be a squeeze-bulb horn. (Courtesy of the Boonsborough Museum of History.)

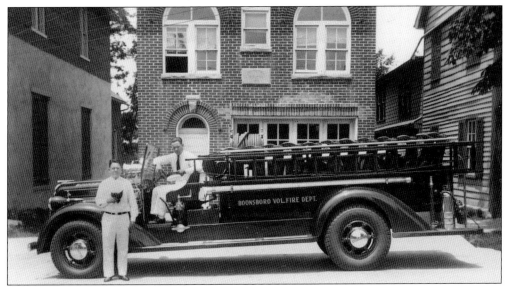

Two volunteer firefighters hold their hats in their hands as they exhibit a town fire truck in front of Boonsboro's fire hall at 11 St. Paul Street about 1940. A concrete marker on its front wall says, "Municipal Building 1912." After a new larger fire hall was built two doors away, the municipal building housed the Boonsboro library from 1948 to 1972. Boonsboro's first fire company was incorporated in 1827. (Courtesy of the Boonsborough Museum of History.)

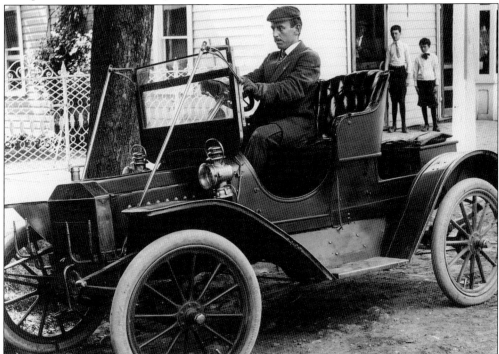

With two young boys looking on from the porch, the driver of Dr. S.S. Davis prepares to pull away in an early Ford about 1915. Displayed on the vehicle are its hand-crank starter, right-side steering wheel, Kelly rubber tires, adjustable windshield, and specialized headlights. (Courtesy of the Boonsborough Museum of History.)

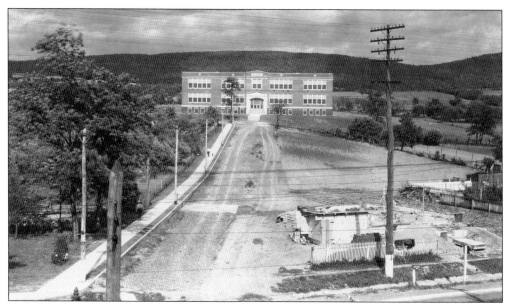

A long concrete sidewalk leads to the former Boonsboro High School building on the east side of North Main Street about 1930. The railway crossing sign at the bottom edge of the image is for the Boonsboro Trolley, which was in operation for the Hagerstown-Frederick Electric Railway Company from about 1902 until 1938. A new high school building replaced this older one in 1958. In 2011, a staff of 80 served 990 students. Hiedwohl's Studio in Hagerstown produced this photograph. (Courtesy of the Washington County Free Library.)

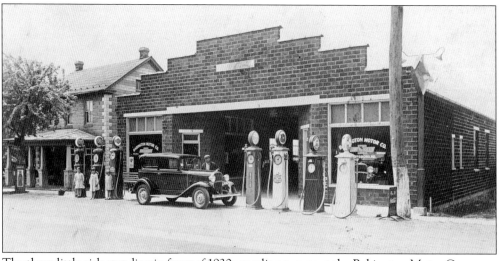

The three little girls standing in front of 1930s gasoline pumps at the Babington Motor Company Chevrolet dealership are, from left to right, Margaret Poffenberger, Lena Babington, and Vivian Babington. Mr. Babington stands behind the latest mid-1930s Chevrolet model at his dealership on the west side of South Main Street. (Courtesy of the Boonsborough Museum of History.)

Two

THE PEOPLE

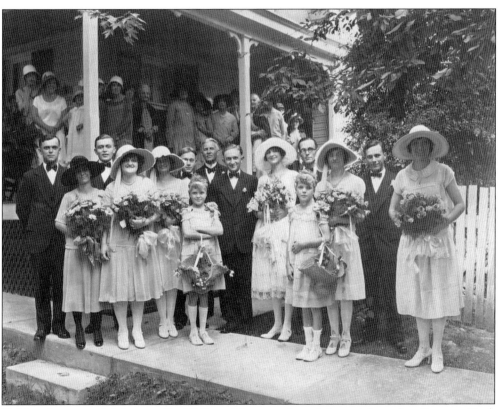

Celebrating a special August 11, 1927, wedding are, from left to right, usher Gorman Ford, organist Maude Wallick, usher Hugh A. Ford, bridesmaids Alleine Ford Snyder and Louise Funk Rice, best man Clifford E. Funk, flower girl Jane Schlosser, the Rev. M.A. Ashby, groom Merle R. Funk, bride Margaret E. "Peg" Itnyre Funk, flower girl Peggy Schlosser, usher Atlee Shifler, maid of honor Geraldine Ford Moser, usher Harold Blickenstaff, and vocalist Lana Chaney Long. (Courtesy of Edwin Itnyre.)

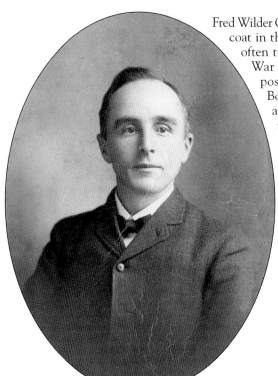

Fred Wilder Cross wears a bow tie and high-buttoned suit coat in this 1925 image. A Civil War expert, Cross often traveled from his home in Boston to Civil War sites to in the Boonsboro area to obtain postwar interviews and photographs. The Boonsborough Museum of History maintains a multivolume collection of Cross's detailed manuscripts. He was born September 15, 1868, and died March 8, 1950. (Courtesy of the Boonsborough Museum of History.)

John Mutius Gaines, seen here in a right-profile portrait from around 1880, was a Confederate surgeon who cared for wounded Confederate soldiers in Boonsboro following the Battles of South Mountain and Antietam. During his stay in Boonsboro, Gaines met Helen Jenette Smith, the daughter of Boonsboro physician Otho J. Smith. Gaines returned to Boonsboro in 1865 to marry Miss Smith before practicing medicine there for the next 28 years. (Courtesy of the Boonsborough Museum of History.)

Wearing an elaborately intertwined, many-textured hat, Mabel Harbaugh Newcomer of the Benevola area north of Boonsboro also shows off a heart-shaped pin on the high neck of her classic outfit about 1900. (Photograph by the King studio of Hagerstown; courtesy of Ruann Newcomer George.)

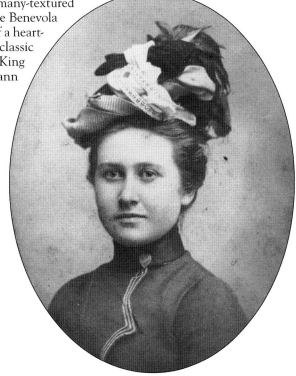

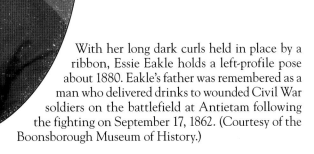

With her long dark curls held in place by a ribbon, Essie Eakle holds a left-profile pose about 1880. Eakle's father was remembered as a man who delivered drinks to wounded Civil War soldiers on the battlefield at Antietam following the fighting on September 17, 1862. (Courtesy of the Boonsborough Museum of History.)

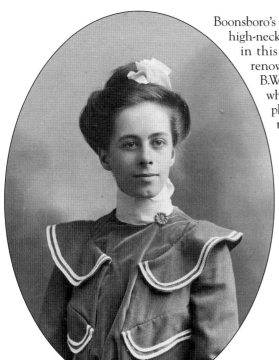

Boonsboro's Effie Foltz wears ribbons in her hair and a high-neck frock enhanced by a small circular brooch in this carefully created late-1800s portrait by renowned Washington County photographer B.W.T. Phreaner (1845–1932). The photographer, whose first name was Bascom, maintained a photographic studio in Hagerstown from 1866 to 1901. (Courtesy of the Boonsborough Museum of History.)

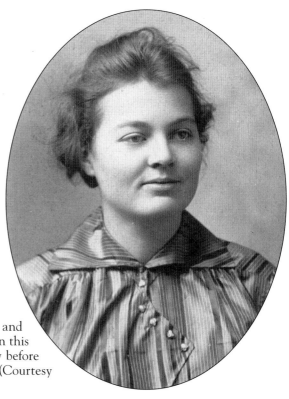

Margaret Recher is wearing a striped and buttoned top and a natural expression in this photograph, taken about 1920, shortly before she married Boonsboro's Earl Itnyre. (Courtesy of Edwin Itnyre.)

Union soldier William R. Gray, age 22, displays his Civil War pistol, rifle, sword, buttoned-up uniform, and kepi hat in October 1863 at Knoxville, Tennessee. Gray was a member of Company B in the 8th Tennessee Regiment volunteer cavalry. The photograph at left shows William later in life wearing a full-brimmed hat, glasses, white goatee, and bow tie. His brother Peter Gray donated his farm and estate to help create the San Mar Children's Home two miles northeast of Boonsboro. A newspaper account reported that Peter Gray's will "provides for the maintenance, education, and training of the white orphan children" of Washington County. Assisted by an 18-member board and a 16-member senior staff, San Mar today offers 10 programs of service focusing on the needs of adolescent and preadolescent girls. (Courtesy of the Boonsborough Museum of History.)

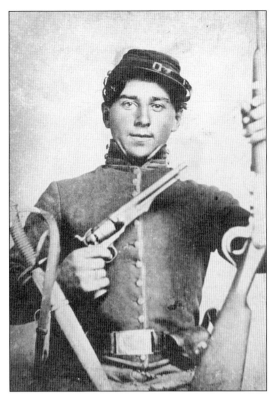

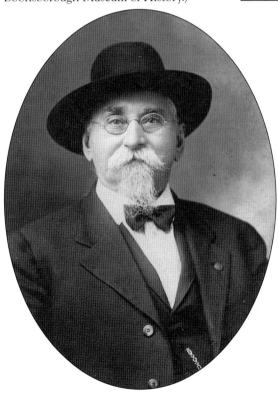

Young Civil War soldier John Lakin of Boonsboro wears his 1860s Union jacket, pants, and kepi cap in front of a photographer's backdrop of a Union flag, cannon, and tent camp scene. It is estimated that of the 2.7 million Union soldiers, more than 2 million were under the age of 21. (Courtesy of the Boonsborough Museum of History.)

Katie Strause Kennedy is buttoned up to a delicate pin at the base of her almost-clerical collar in this late-1800s photograph by the A.L. Rogers studio in Hagerstown. Born in 1855 and married in 1891, Kennedy was the sister of Molly Strause Itnyre of Boonsboro. (Courtesy of Edwin Itnyre.)

Two wide feathers in a nest of lace and satin sprout from Louise Reuter's flattened hat, which is sprinkled with small sparkle dots and complements the wide lapels, lace, and puff sleeves of her fashionable late-1800s dress. Reuter was a regular summer visitor to Boonsboro from her home in New York City. (Photograph by B.W.T. Phreaner of Hagerstown; courtesy of the Boonsborough Museum of History.)

George Alfred Townsend, a popular novelist and the Civil War's youngest newspaper field correspondent, constructed his unusual War Correspondents Arch in 1892 on his 100-acre estate at Crampton's Gap, where furious fighting took place during the Battle of South Mountain in 1862. The War Correspondents Arch is 50 feet high and 40 feet wide and is a key attraction at Maryland's Gathland State Park, southeast of Boonsboro. (Courtesy of the Washington County Free Library.)

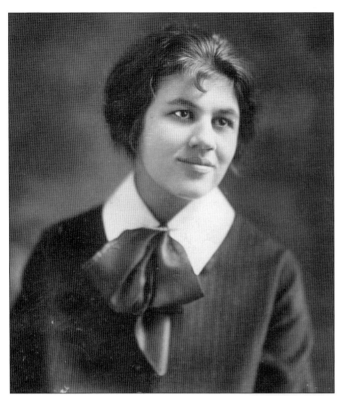

Florence Sinnesin wears a wide collar and satin bow in her Boonsboro High School class of 1925 portrait. After college, Sinnesin became an elementary schoolteacher and served as coauthor Doug Bast's third-grade teacher. (Courtesy of the Boonsborough Museum of History.)

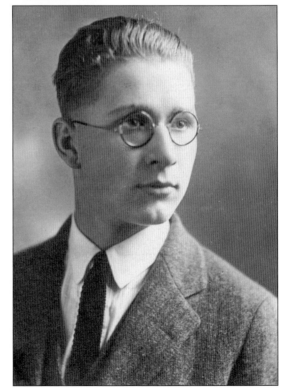

Glenn Stouffer wears round professorial glasses, a narrow knit tie, and a tweed suit coat and vest for his Boonsboro High School class of 1925 portrait. (Courtesy of the Boonsborough Museum of History.)

Captured here with his bushy trademark mustache and a double-breasted suit in the 1920s, T.L. Stine was a dealer and operator of carousels and other "amusements furnished for parks." Based in the unincorporated village of Trego, about seven miles south of Boonsboro, the T.L. Stine Amusement Company manufactured the popular Double-Whirl carousel, which offered "wave-like motions never before attempted." (Courtesy of the Boonsborough Museum of History.)

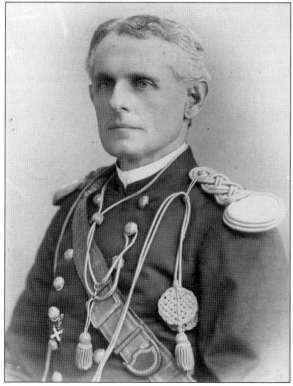

Henry Kyd Douglas (1838–1903), a Washington County native and Hagerstown lawyer, is seen here in his uniform as adjutant general of Maryland in this 1890s photograph by Rogers and King studio in Hagerstown. A staff officer for famous Confederate general Thomas "Stonewall" Jackson, Douglas, in his book, *I Rode With Stonewall*, tells about Stonewall Jackson's near-capture in Boonsboro in 1862. (Courtesy of the Boonsborough Museum of History.)

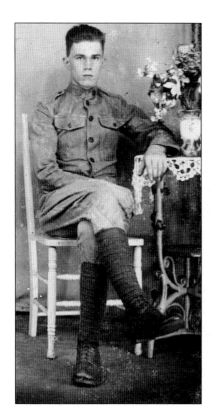

In his Army uniform, boots, and wrapped leggings, young Ralph Coombs of Boonsboro rests his arm next to a vase of flowers on an ornate lace-topped table as he poses for a postcard photograph while on duty in Panama on April 10, 1923. (Courtesy of the Boonsborough Museum of History.)

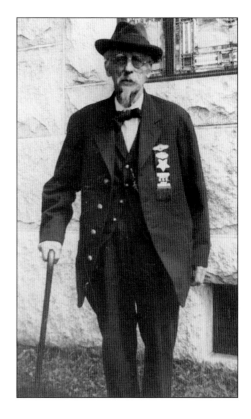

Civil War veteran William Henry Kline of Boonsboro, wearing a hat, glasses, bow tie, and suit, leans on his cane, displaying some of his military service medals in the early 20th century. The last surviving Union veteran of the Civil War was Albert Woolson, who died in 1956 at the age of 109. (Courtesy of the Boonsborough Museum of History.)

A handsome, serious, but unidentified
World War I soldier displays his uniform
and Army service hat. (Courtesy of the
Boonsborough Museum of History.)

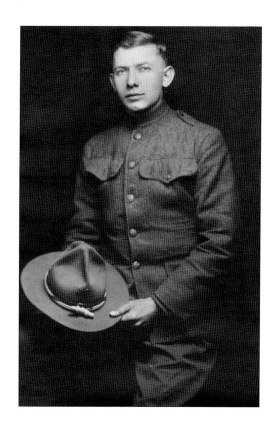

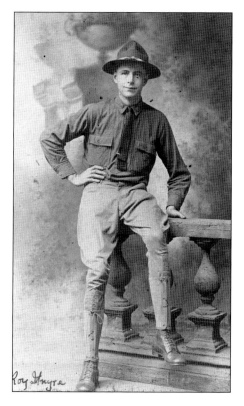

Roy Itnyre poses in his National Guard uniform
during a 1912 visit to his Boonsboro home from
National Guard service on the Mexican border.
Called up for World War I military duty from 1916
to 1918, Itnyre also served at Camp McClellan in
Anniston, Alabama. (Courtesy of Edwin Itnyre.)

With his hair closely cropped, Harry Newcomer wears a tie, glasses, wedding band, and has a white handkerchief peeking out of his business suit in the 1930s. Newcomer had close family ties to the Newcomer Mill north of Boonsboro. He helped launch the Hagerstown Grocery Company in the early 1900s and served as Washington County's register of wills for more than 30 years. (Courtesy of Ruann Newcomer George.)

Cabinetmaker Howard Rowe of Boonsboro wears the stiff straw boater or skimmer hat of a typical Southern gentleman in the early 20th century. Rowe completes the look with his casually open suit and polka-dot bow tie. He learned the cabinetmaking trade at the Bast of Boonsboro furniture store. (Courtesy of the Boonsborough Museum of History.)

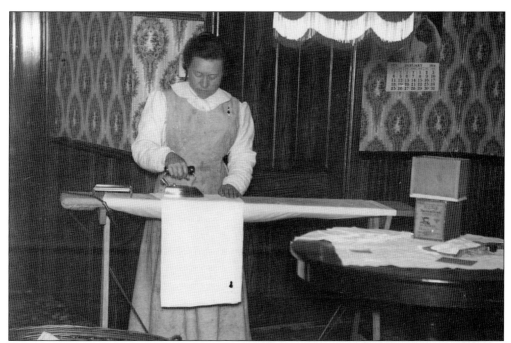

A calendar on the wall indicates that it is January 1914 as Lucy Young wears a long-sleeved top and long dress to do her ironing beneath a fringe-bedecked hanging lamp in her home on North Main Street. She was married to Boonsboro photographer Cadville D. "C.D." Young, who created this glass-plate negative photograph. (Courtesy of the Boonsborough Museum of History.)

Agnes Murphy's bright early-20th-century dress included a turtleneck collar; long, soft sleeves; a large rectangle belt buckle; and buttons from top to bottom of her lightly striped full-length skirt. At the time, this dress was a fashion statement. (C.D. Young photograph; courtesy of the Boonsborough Museum of History.)

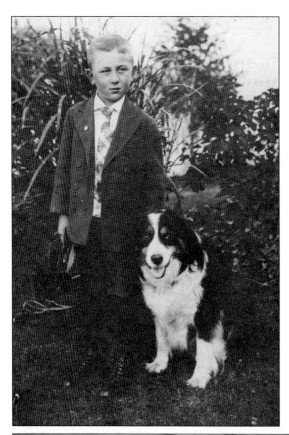

Wearing a coat, tie, and shiny high-top shoes, young Boonsboro boy Denver Wyand poses with his dog (left) before putting his flat hat back on to sit astride his horse (below) for photographer C.D. Young about 1913. (Both, courtesy of the Boonsborough Museum of History.)

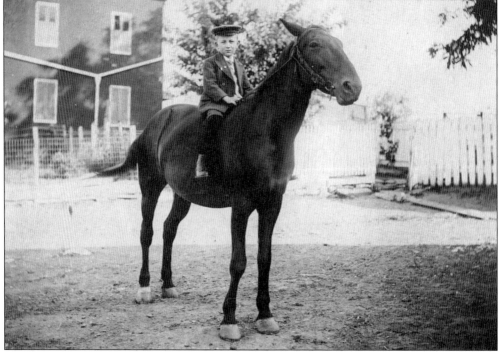

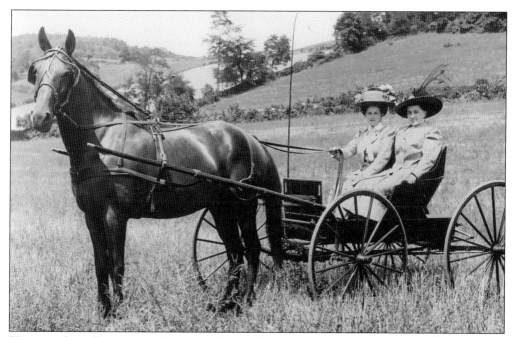

Wearing a large flower-covered bonnet, this well-dressed woman holds the reins while her equally fashionable passenger in a feathered hat holds the side of her carriage seat. Their horse turns its head on cue during a sunny ride through the Boonsboro-area countryside in the early 1900s. (Courtesy of the Boonsborough Museum of History.)

Joshua E. Moser steadies his carriage horse as his wife, Mary Magdalene Foltz Moser, looks on from the porch of their home off El Rancho Road near the nearby village of Mapleville around 1900. (Courtesy of Edwin Itnyre.)

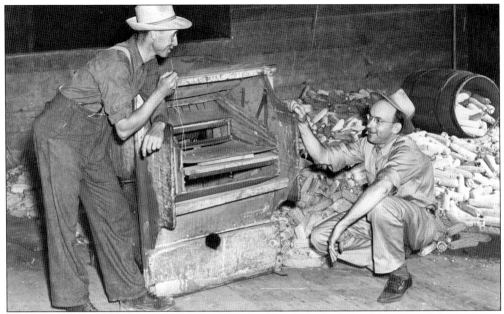

Richard H. Newcomer (left) and a neighbor known simply as Mr. Altemier conduct a hands-on discussion of a wheat-cleaning machine in the 1940s. Altemier designed and constructed the wheat-cleaning machine for Newcomer to use on his farm in Benevola, about three miles north of Boonsboro. The machine worked well, and Newcomer put it to good use in his barn, according to his daughter Ruann Newcomer George, who still lives on the family farm. (Courtesy of Ruann Newcomer George.)

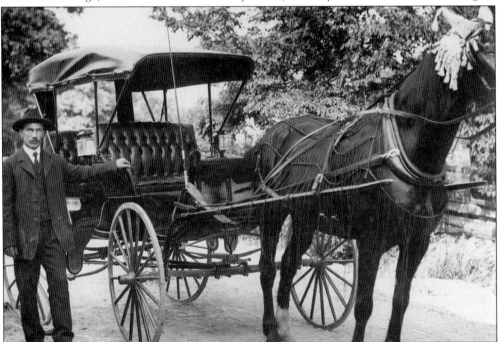

Harvey Huntzberry of Boonsboro wears a formal hat, suit, vest, and tie as he displays his covered four-passenger buggy with side lights and a fly-protected horse around 1900. (Courtesy of the Boonsborough Museum of History.)

A well-dressed unidentified woman strikes a wedding portrait pose as she rests her right hand on the left shoulder of a dirt-smudged snowman along Boonsboro's Potomac Street in the early 20th century. The furry skin of a fox is draped around her neck, and its head and bulging eyes hang just below her chin. She carries a very large matching fox fur muff and also wears a soft-textured hat and a full-length black lambskin coat. (Courtesy of the Boonsborough Museum of History.)

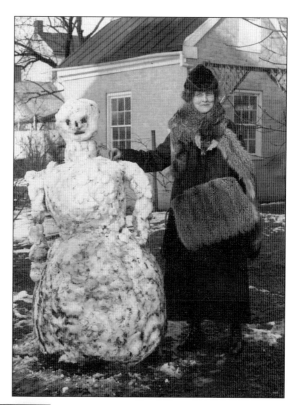

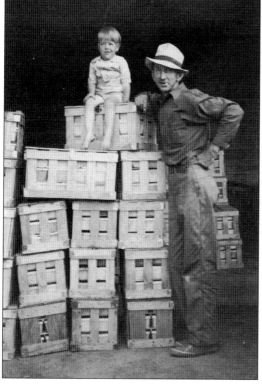

Jerry Lee Itnyre and his father, Earl Itnyre, show off their market-ready crates of raspberries in Boonsboro about 1930. "The town was a big berry market in season," reported Earl's brother Edwin Itnyre. "Back then when I was a kid everybody had berries around here. On both sides of the street in Boonsboro there were stacks of berry crates waiting to be trucked out to Pittsburgh." (Courtesy of Edwin Itnyre.)

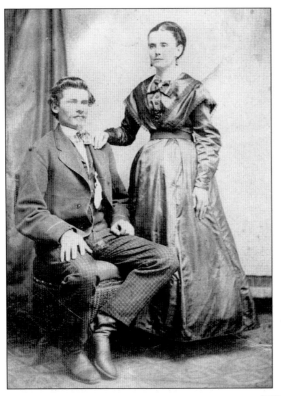

Minnie A. Davis rests her hand on the shoulder of the Rev. John C. Bowman as they celebrate their wedding at the Reformed Church in Boonsboro on Tuesday, January 8, 1878. According to their wedding announcement, Minnie Davis was the youngest daughter of the late Capt. Elias Davis of Boonsboro. The Reverend Bowman was pastor of the Reformed Church of Shepherdstown, West Virginia. Rev. Simon S. Miller performed the Boonsboro wedding service. (Courtesy of Edwin Itnyre.)

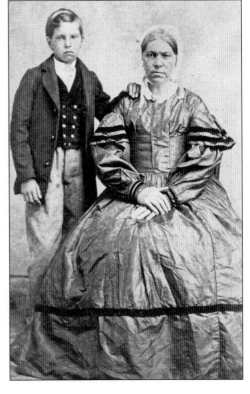

Dressed in a heavy three-button coat over a special 10-button vest, an unidentified boy rests his hand on the shoulder of an older woman wearing not only a formal head covering but also a long-sleeved, wide-based, full-skirt dress with stripes in the late 1800s. (Courtesy of the Boonsborough Museum of History.)

Wearing a satin textured dress with massive puffy shoulder sleeves, Flora Wyand stands beside her husband, Harry Wyand, who wears a white tie and tuxedo and sits on a Victorian-era wicker chair, for this B.W.T. Phreaner photograph in the late 1800s. The Wyands lived on South Main Street. (Courtesy of the Boonsborough Museum of History.)

Barefoot baby Edwin Itnyre sits on a comfy booster cushion as he and his older sister Norma hold the arm of a hand-tooled photographer's studio bench in the early 1900s. Norma is wearing high-top stockings and a new pair of dressy shoes. (Courtesy of Edwin Itnyre.)

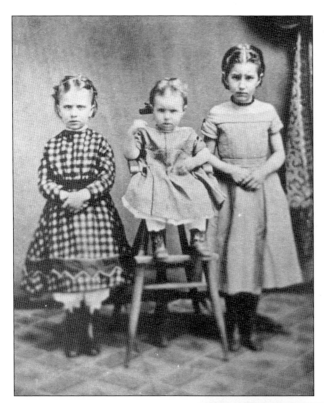

Three fashionable 19th-century girls wear dresses of a broad checkered pattern, the latest in high chair and pantaloon attire, and an off-the-shoulder look complete with a snug beaded necklace at the J.H. Wagoner Photographic and Ferrotype Gallery in Boonsboro in the mid- to late 1800s. (Courtesy of the Boonsborough Museum of History.)

A smiling D.W. "Grandpapa" Foltz holds his expressive barefoot granddaughter Lena Emmert on his lap around 1917. (Courtesy of the Boonsborough Museum of History.)

With their hair carefully pinned back, sisters Lena (left) and Cora Newcomer wear matching satin-textured dresses with thin vertical stripes; lace-covered, pointed and trimmed, smooth fur harlequin collars; and puffy shoulder top sleeves about 1900. The sisters were from Benevola, about three miles north of Boonsboro on the National Road. (Courtesy of Ruann Newcomer George.)

With his white hair and full white beard, an elderly Joshua Flook has his hand on his cane as he wears a heavy suit and a striped vest outdoors in Boonsboro around 1914. Seated next to him, Flook's wife wears a carefully stitched dark dress and watches through metal-rimmed glasses. (Courtesy of the Boonsborough Museum of History.)

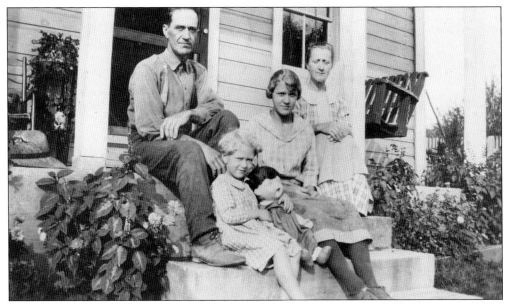

With a small chair and porch swing behind them and lots of plants around them, Mr. and Mrs. Carlton E. Gross and their daughters, Emma and Iona, sit on the front steps of their South Mountain home southeast of Boonsboro in 1924. Union and Confederate troops during the Battle of South Mountain in 1862 fought on this property, once known as the Henry Gross homestead. (Photograph by Fred Wilder Cross; courtesy of the Boonsborough Museum of History.)

Earl Itnyre (left) and his brother Roy wear special bow ties as they stand on either side of their mother, Mary "Molly" Strause Itnyre, in the early 1900s. Molly Itnyre was married to Edward "Ed" Itnyre of Boonsboro. (Courtesy of Edwin Itnyre.)

With small smiles all around, three unidentified members of the Itnyre family are dressed for cold weather in Boonsboro about 1930. The man wears a wool flat cap, shiny shoe boots, a tie, and a topcoat over his suit and vest. His wife wears a warm, ear-covering winter hat, round dark-framed glasses, and a wide-collared winter coat. Their child wears a bright ear-covering hat and a coat with a mini-cape top. (Courtesy of Edwin Itnyre.)

A girl steadies a tree limb on a sawhorse as two boys operate a long two-handled band saw to make firewood logs in Boonsboro about 1915. The small child looking on appears to be in charge of pulling newly sawed logs away from the operation. (Photograph by C.D. Young; courtesy of the Boonsborough Museum of History.)

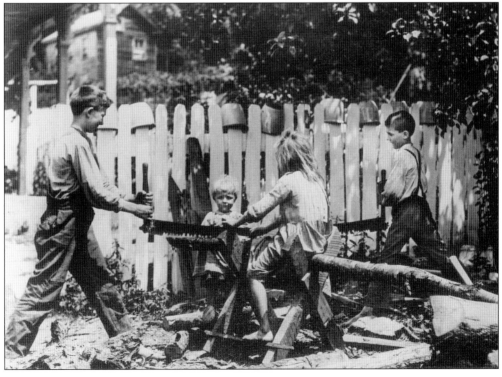

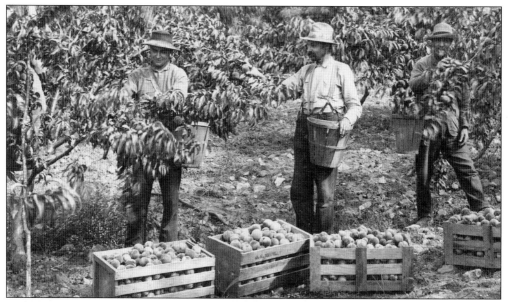

Wearing hats to shield their faces from the sun, four men work at filling their shoulder baskets near Boonsboro in the early 20th century. In front of them, four crates full of peaches illustrate the success of the workers' efforts on behalf of the owner, J.S. Snively of Hagerstown. (Photograph by C.D. Young; courtesy of the Boonsborough Museum of History.)

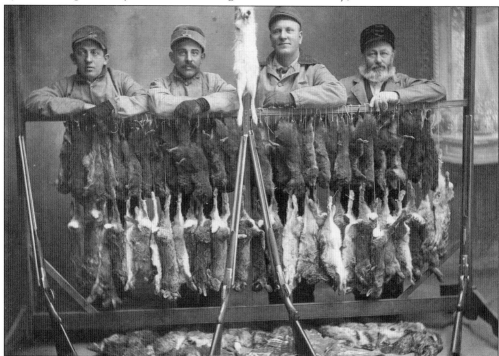

Lewis E. Sumam (right) and his three sons stand by their four double-barrel shotguns and the results of a rabbit-and-squirrel hunt in the early 1900s. Sumam was the owner of a funeral home in Keedysville, located about three miles west of Boonsboro. (Courtesy of the Boonsborough Museum of History.)

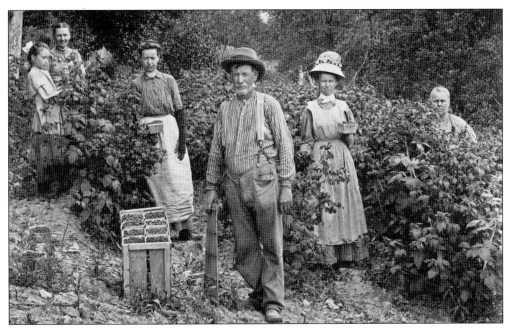

Two members of the picking team hold full pint containers of raspberries on either side of Joe Brown as he holds the lid to a case of full raspberry containers. Three other pickers are up to their shoulders in work and raspberry bushes on Brown's Mousetown farm just southeast of Boonsboro about 1914. (Photograph by C.D. Young; courtesy of the Boonsborough Museum of History.)

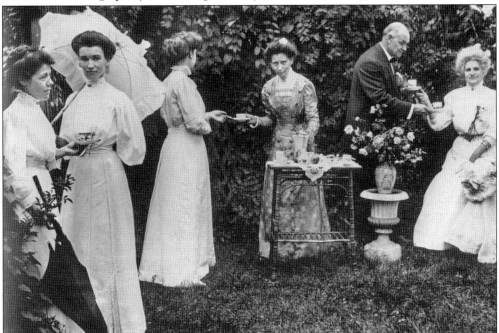

Five women wearing fine long gowns join a man in a suit and tie for a Boonsboro backyard tea party in the late 1800s. In addition to the teacups and saucers, the group's other party props include a parasol, a lace-covered table, and a vase full of roses. (Courtesy of the Boonsborough Museum of History.)

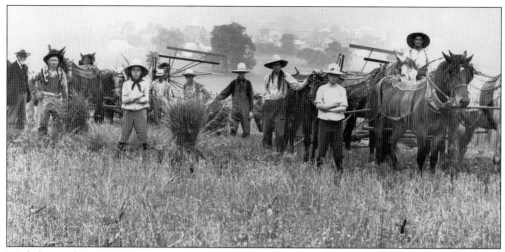

With horse-drawn equipment standing at the ready, a multigenerational group of 10 men in wide-brimmed hats pauses during harvesting work in a wheat field near Boonsboro about 1915. (Photograph by C.D. Young; courtesy of the Boonsborough Museum of History.)

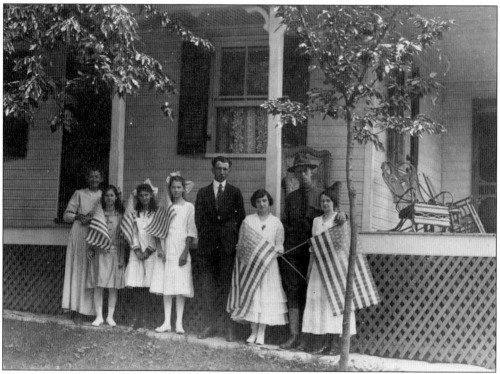

Flanked by two unidentified orchestra musicians from New England, Roy Itnyre wears his National Guard uniform during a 1912 visit to his family home at 34 St. Paul Street. Joining the soldier and his two female musician friends are, from left to right, Roy's mother, Molly Itnyre; Freda Martz; Ella Wilhide; Margaret "Peg" Itnyre, Roy's sister; and Earl R. Itnyre, Roy's brother, who also served for the National Guard along the Mexican border. (Photograph by C.D. Young; courtesy of Edwin Itnyre.)

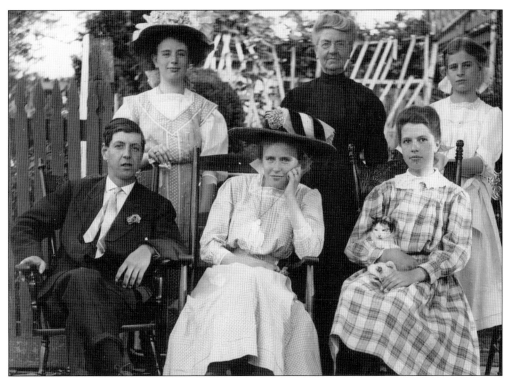

One man and five women, two in fancy hats and one with a cat, pose about 1915. The cat is almost lost against the large plaid dress pattern of the young woman at right in the first row, while the summer dresses and the pair of fancy hats counterbalance the suit and tie of the man, who appears to have a rose in his lapel. (Courtesy of the Boonsborough Museum of History.)

These Boonsboro public officials, seen about 1950, are, from left to right, (first row) Joseph S. Clopper, town councilman; John B. Wheeler, mayor; and L. Dewey Warrenfeltz, assistant mayor; (second row) Elmer G. Miller, town clerk; and town councilmen Albert E. Sinnisen, Olin E. Snyder, and Clarence W. Foltz. Wheeler served as mayor of Boonsboro from 1942 to 1960. (Courtesy of the Boonsborough Museum of History.)

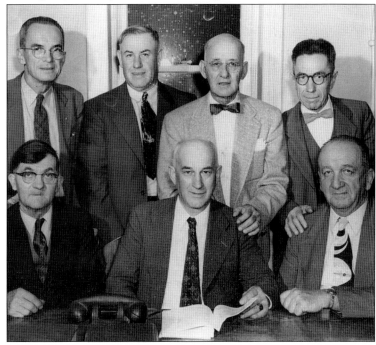

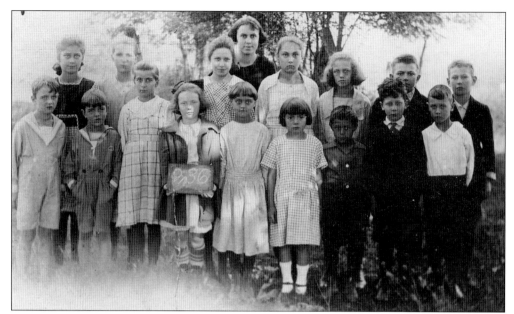

A handwritten inscription on the original copy of this photograph reads, "Benevola School, September 28, 1922, Janice Wilson – Teacher." A sign held by a student in the first row identifies their school as No. 36 in the Washington County School System. Located just north of Boonsboro near the crossroads village of Benevola, the school was also known as Harmony Hill School. (Courtesy of Ruann Newcomer George.)

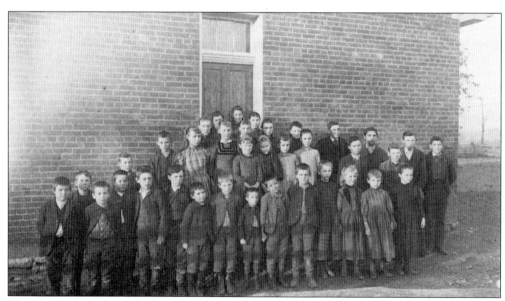

Wearing a coat and standard tie around 1889, teacher Vincent Flook stands with his 35 students at Harmony Hill School. (Courtesy of Ruann Newcomer George.)

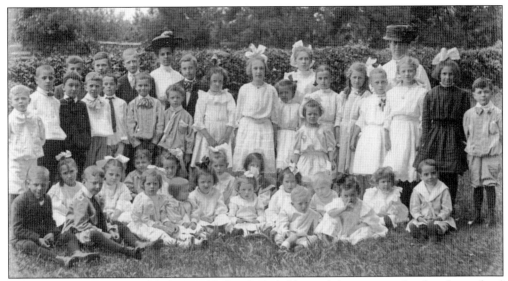

Two women in large period hats stand behind 40 children of elementary school and preschool age in the early 1900s. Many of the girls wear ribbons in their hair, whereas the boys wear a wide variety of neckties. (Courtesy of the Boonsborough Museum of History.)

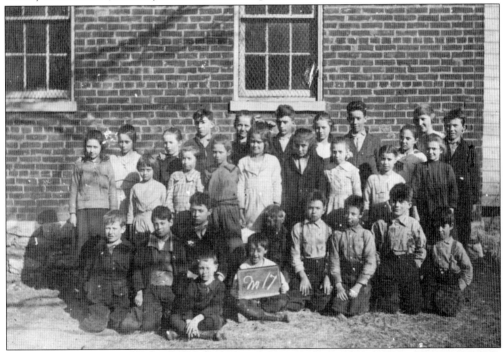

Students at Benevola's Harmony Hill School in 1921 included, from left to right, (first row) Wilbur Baker, ? Johnson, ? Johnson, Richard H. Newcomer, Ralph Weller, unidentified, Edward Snyder, William Weller, Charles Harshman, and Robert Weller; (second row) Gladys Reeder, Iva Turner, Catherine Reeder, Margaret Fisher, ? Biser, ? Biser, Ima Dubel, and unidentified; (third row) Catherine Newcomer, Ruth Weller, Catherine Turner, Glenn Turner, Lela Smith, John Turner, Ethel Reeder, Rowland Reeder, May Weaver, teacher Agnes Lindsay, and John Gross. (Courtesy of Ruann Newcomer George.)

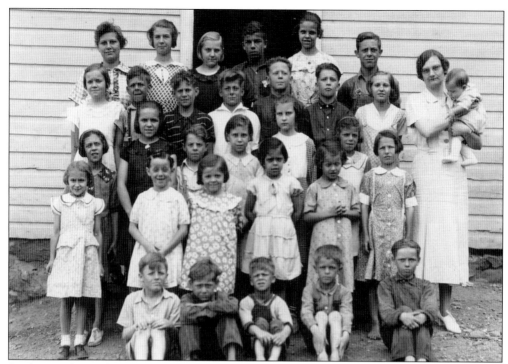

Students gather at the entrance to their Boonsboro public school as their teacher, Mrs. Geltmarker, holds onto a squirming future student about 1950. (Photograph by Gerald D. Bast; courtesy of the Boonsborough Museum of History.)

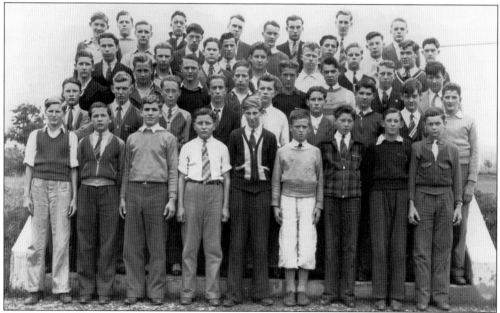

Among these Boonsboro High School boys in the 1940s is Richard Haynes (fourth row, far right). Haynes became a manager of the Boonsboro Post Office. He served for more than 40 years as the director of the historical Rohrersville Cornet Band of Washington County. (Courtesy of the Boonsborough Museum of History.)

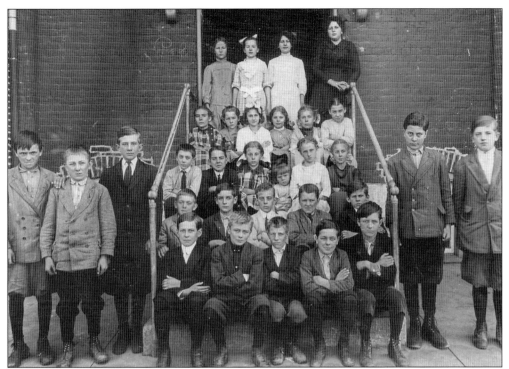

Thirty students and their teacher gather at the entrance to the Boonsboro Public School on Potomac Street about 1900. At the time, elementary school boys were expected to wear short pants. Referred to in 1877 as "Public School No. 7" in *An Illustrated Atlas of Washington County, Maryland*, the Potomac Street school building is now an apartment building. (Courtesy of the Boonsborough Museum of History.)

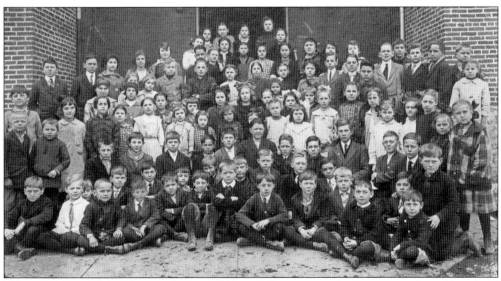

This large group of about 100 students and their teacher poses at the entrance to the public school on Potomac Street about 1900. The building was a furniture store warehouse and currently serves as an apartment building. (Courtesy of the Boonsborough Museum of History.)

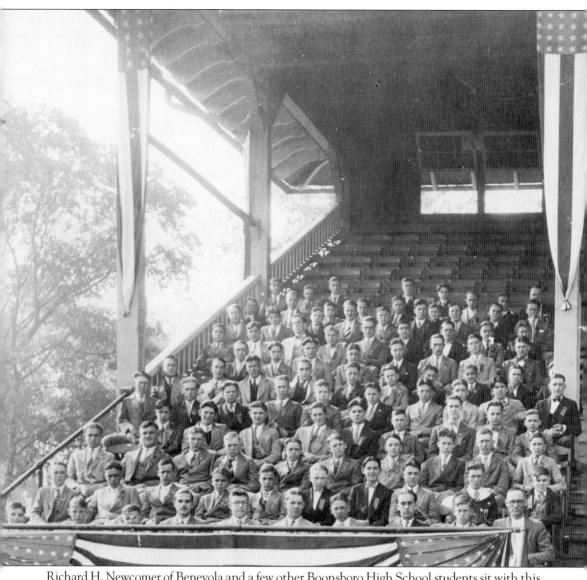

Richard H. Newcomer of Benevola and a few other Boonsboro High School students sit with this group of 180 men and boys at a 1930s Future Farmers of America (FFA) regional gathering at the Frederick fairgrounds, 20 miles southeast of Boonsboro. Boonsboro High School still maintains

an active FFA chapter dedicated to all aspects of agricultural education. Started in 1928, the national FFA organization had 550,000 members and 7,500 chapters in 2011. (Courtesy of Ruann Newcomer George.)

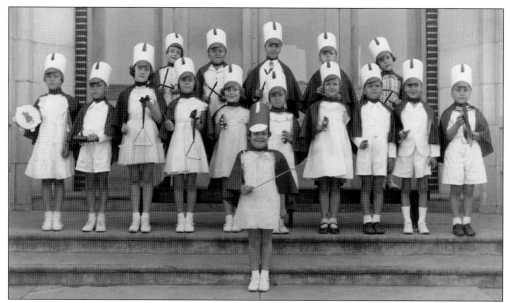

Dressed in special high hats and capes on the front steps of the old Boonsboro High School building, this smiling group of elementary school music-makers features one tambourine, two triangles, three sets of hand-held bells, a pair of small cymbals, and numerous clacker sticks. Before it was demolished, the old three-level brick building was actually three schools under one roof. A new Boonsboro High School opened in 1958. (Photograph by Gerald D. Bast; courtesy of the Boonsborough Museum of History.)

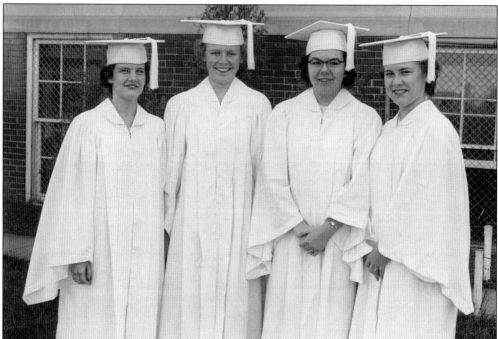

The Boonsboro High School graduating class of 1951 included, from left to right, Helen Benson, Elizabeth Elgin, Lorraine Garnand, and Peggy Sigler. (Photograph by Frank Kelley; courtesy of the Boonsborough Museum of History.)

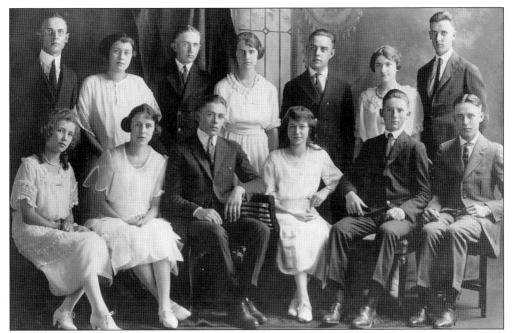

The 13 members of the Boonsboro High School class of 1922 are, from left to right, (first row) Kathleen Gantz, Lois Wilson, Hugh A. Ford, Naomi Biser, Lester Doyle, and Harold Blickenstaff; (second row) Atlee Shifler, Frances Alexander, Merle Funk, Thelma Keadle, Paul Snyder, Delilah Keadle, and Bailey Nelson. (Courtesy of Edwin Itnyre.)

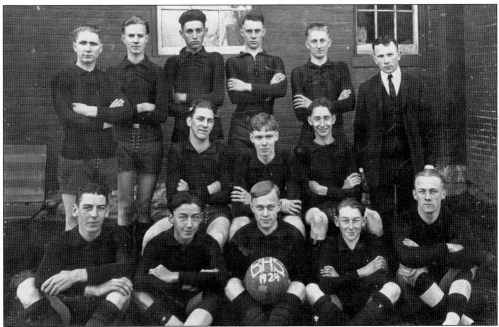

The 14 members of the 1924 Boonsboro High School soccer team were, from left to right, (first row) Edwin Kline, John Lakin, Clifford Funk, Russell Kepler, and Frank Summers; (second row) Joe Ridenour, James Renshaw, and Bailey Nelson; (third row) Glenn Stouffer, Bob Wyand, Bob Lakin, unidentified, ? Moser, and coach ? Castle. (Courtesy of Ruann Newcomer George.)

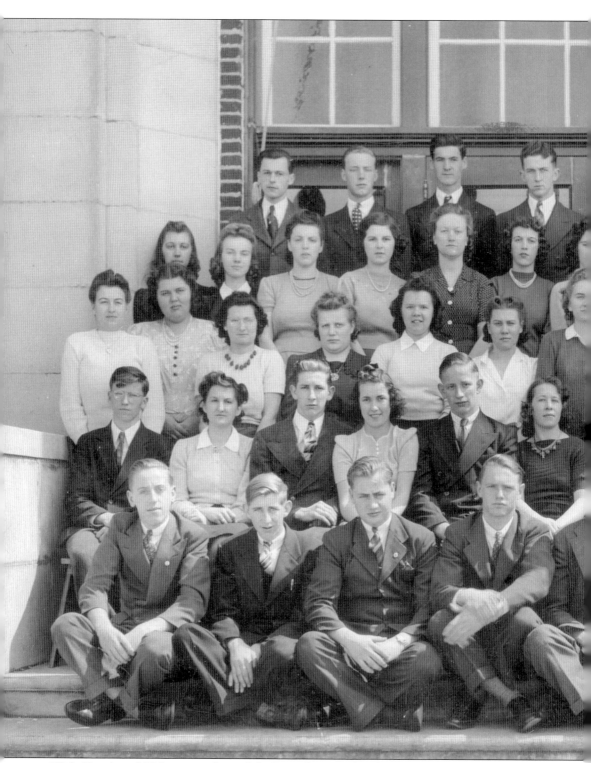

With 32 girls and 22 boys, members of the Boonsboro High School class of 1942 gather on the front steps of their school. Located at the end of a lane on the east side of North Main Street,

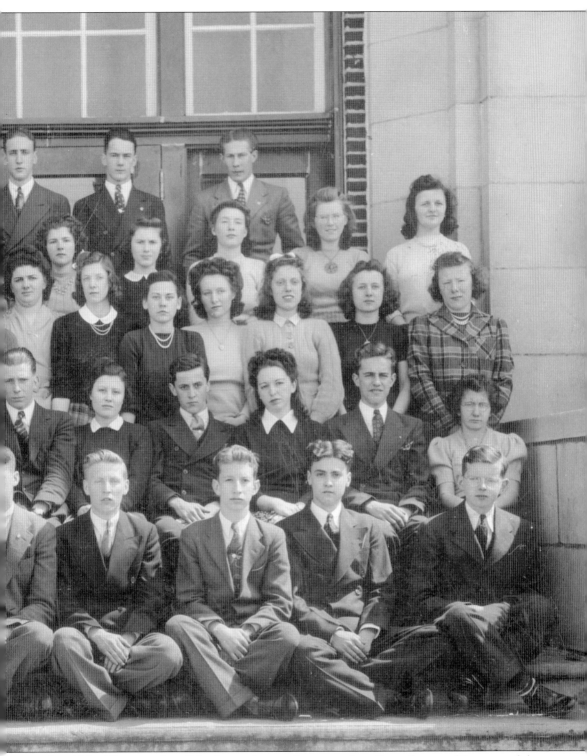

the old building was demolished to make way for a complex of townhouses. (Courtesy of the Washington County Free Library.)

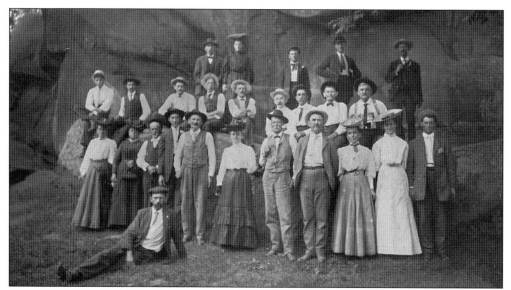

A group of 26 Boonsboro visitors gathers on the Civil War battlefield at Gettysburg about 1900 after traveling by railroad from Hagerstown. The standing group includes, from left to right, (first row) Mrs. ? Nicodemus, Mr. and Mrs. John Fletcher, unidentified, Tom Lynch, Mr. and Mrs. Jesiah Blecher, and four unidentified people; (second row) three unidentified men, Paul Miller, ? Lemon, two unidentified men, Lem Cline, and an unidentified man; (third row) Mr. and Mrs. John Miller and three unidentified men. The man seated in front is also unidentified. (Courtesy of the Boonsborough Museum of History.)

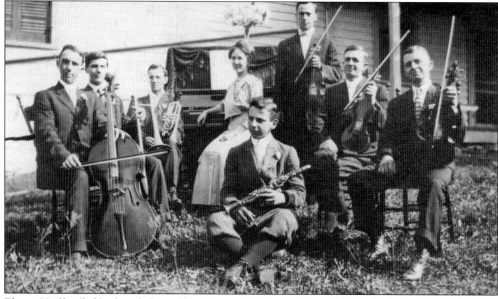

Elmer Huffer (left) played the cello, Minnie Schlosser (center) played the piano, and Clyde Thomas (standing) played the violin in the Monroe Orchestra in the early 1900s. Thomas owned Thomas Awning Company in Boonsboro. The five other unidentified members also performed with the community orchestra based in the small village of Monroe, found about two miles west of Boonsboro at the intersection of Wheeler, Mill Point, Monroe, and Manor Church Roads. (Courtesy of Ruann Newcomer George.)

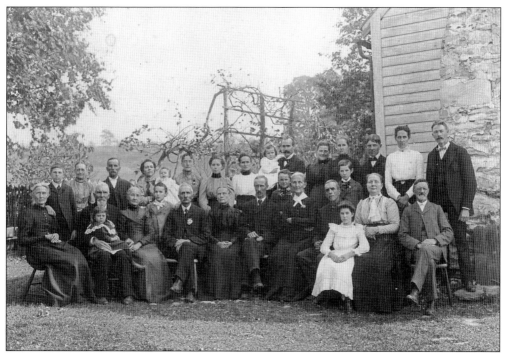

Four or five generations of Boonsboro's Foltz and Ocker families line up in coats and ties or high-neck dresses and long skirts in front of the grapevines on the stone chimney side of a house about 1900. (Courtesy of the Boonsborough Museum of History.)

This 1930s group photograph by C.D. Young of Boonsboro includes area notables such as Albert Mullendore and John B. Wheeler, the mayor of Boonsboro from 1942 to 1960. (Courtesy of the Boonsborough Museum of History.)

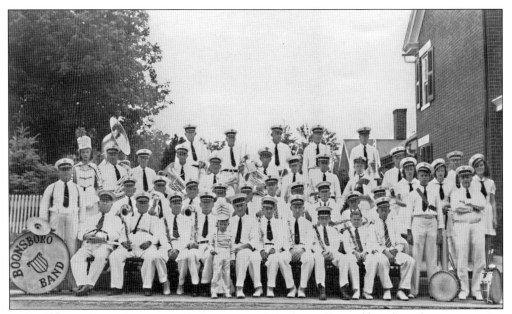

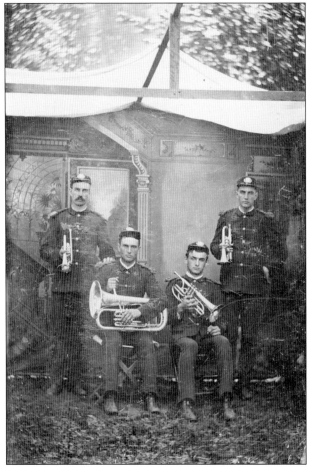

Framed by a bass drum, two snare drums, a tuba, and at least five clarinets, the members of the Boonsboro Band wear white uniforms, white hats, and dark ties about 1950. One of the band's four female members is in a drum major's uniform. A young boy in the first row also is dressed as a drum major. (Courtesy of the Boonsborough Museum of History.)

Four Boonsboro Band members hold period instruments for a time-exposure photograph about 1890. Calvin Flook is seated on the left. Vincent Flook is standing on the right, but the two other band members are not identified. (Courtesy of the Boonsborough Museum of History.)

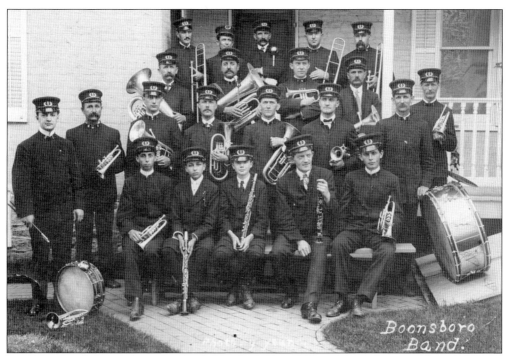

In June 1909, the Boonsboro Band included, from left to right, (first row) Fred Ford, Louis Young, John Bast, Doyl Moore, and Carl Stouffer; (second row) Cloyd Dean, John Wallick, Charles Meredith, Edward Gantz, John Cline, Roy Eavey, Charles Smith, and Frank Martz; (third row) Rufus Morgan, Earl Glenn, Bela Warrenfeltz, and Calvin Flook; (fourth row) Vincent Flook, Charles C. Ford, Charles Strause, Rush Flora, and Oscar Grossnickkle. (Photograph by Cadville D. Young; courtesy of the Boonsborough Museum of History.)

On the battlefield at Gettysburg about 1889, Boonsboro Band members included, from left to right, (first row) Frank Martz, ? Febrey, Calvin Flook, George Febrey, Vincent Flook, director Howard Flook, and ? Febrey; (second row) Charles C. Ford, Charles Koogle, James K. Polk Itnyre, Dick Ford, Otho J. Ford, Fred Flook, and Harley Herr; (third row) Harvey Storm, William F. Bast, Ellsworth Ford, and ? Biser. (Courtesy of the Boonsborough Museum of History and the Washington County Free Library.)

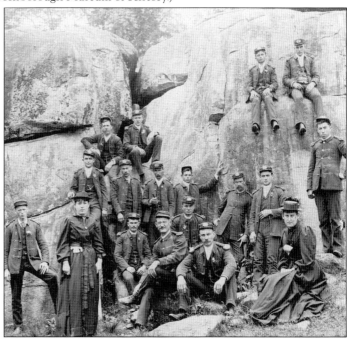

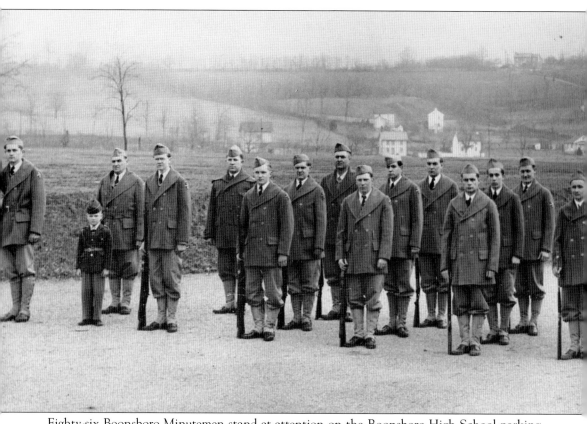

Eighty-six Boonsboro Minutemen stand at attention on the Boonsboro High School parking lot with "guide-on" flag bearer Edwin Itnyre on the far left in the early 1940s. A home guard

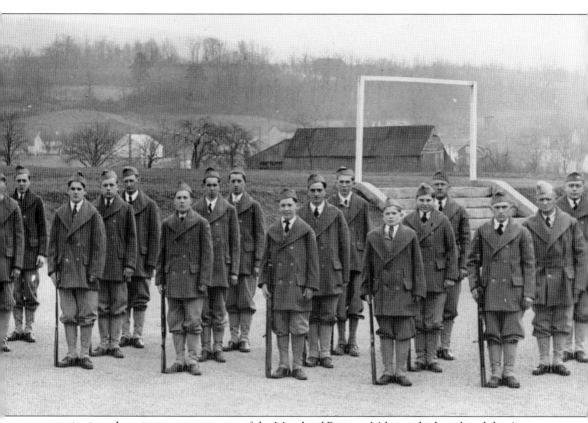

organization, the minutemen were part of the Maryland Reserve Militia, which replaced the Army National Guard when it was mobilized during World War II. (Courtesy of Edwin Itnyre.)

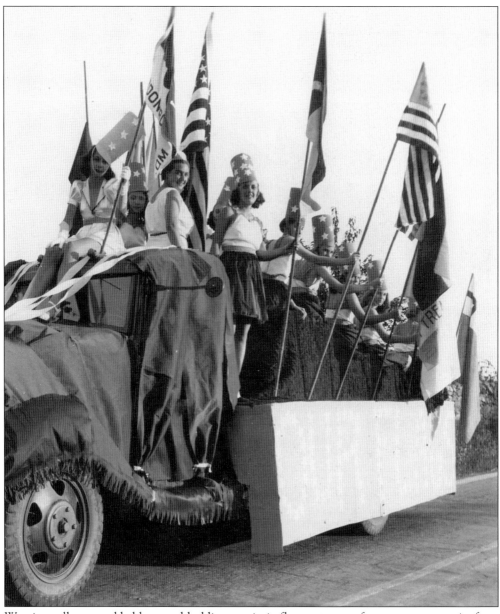

Wearing tall star-studded hats and holding patriotic flags, a group of young women waits for a Boonsboro parade to start in the 1940s. The group's "Our Flags" float appears to be a cleverly disguised World War II truck. (Courtesy of the Boonsborough Museum of History.)

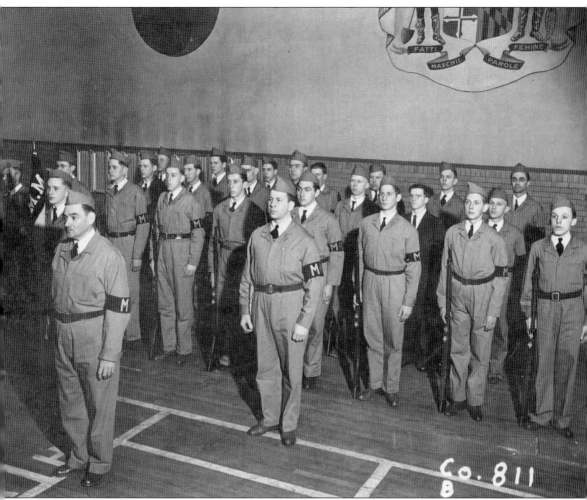

Led by Capt. John Hershberger (left front), members of Boonsboro Minutemen Company B stand at attention in the Hagerstown National Guard Armory in 1943. From left to right, they are (first row) Sgt. Bruce Blueball, James Beeler, and Lt. Keller Ridenour; (second row) John Bast Jr., Edwin Itnyre, Harold Dagenhart, Frank Wolfe, Thomas Clopper, Dennis Reeder, Robert Swain, and Paul Jones; (third row) Lloyd Ford, Charles Root, John Summers, Glen Ridenour, Walter Samsai, and Jake Funk; (fourth row) Frank Summers, Ralph Shifler, Donald Shifler, Roger Scott, Jack McNight, William Donaldson, and Foster Ford. Hershberger served as Boonsboro's mayor from 1938 to 1942. Ford was a teacher in Boonsboro. Dagenhart was killed after the D-Day Invasion of France in 1944. The Boonsboro Minutemen were part of the Maryland Reserve Militia, who took the place of the National Guard after it was absorbed into the US Army during World War II. (Photograph by Kelley Studio of Hagerstown, Maryland; courtesy of Edwin Itnyre.)

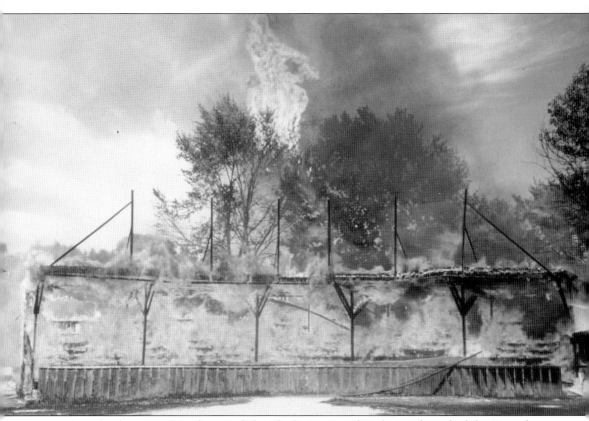

A fire of unknown origin destroyed the Shafer Memorial Park grandstand of the Boonsboro Yellow Jackets amateur baseball team in the mid-1940s. The 1946 team included outfielder Richard Schlotterbeck, second baseman Thomas Knode, outfielder Bernard Barger, relief pitcher Harry Schlotterbeck, pitcher Dennis Reeder, catcher Drake Dofflemeyer, catcher Roger Scott, third baseman Richard Griffith, manager and outfielder "Snub" Rowe, outfielder Richard Guyton, pitcher Bernard Young, first baseman Paul Norris, utility player "Gumball" Reeder, shortstop Frank Spielman, and pitcher Charles Brown. (Photograph by Gerald D. Bast; courtesy of the Boonsborough Museum of History.)

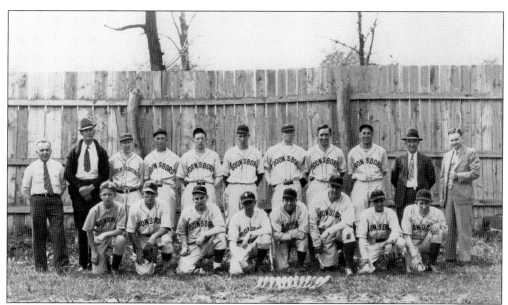

The Boonsboro Yellow Jackets amateur baseball team gathers in front of an outfield wall in this 1940s photograph by Gerald D. Bast of Boonsboro. Mayor John Wheeler on the right wears a suit, tie, and hat. "Happy" Huffer is on the far left. The others are unidentified. (Courtesy of the Boonsborough Museum of History.)

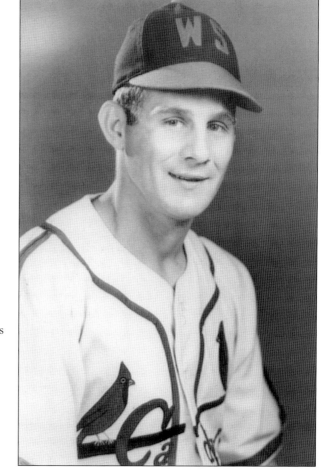

Dennis Reeder of Boonsboro wears a St. Louis Cardinals uniform during his tenure as a Major League Baseball player in about 1940. Reeder's family operated a popular grocery store on the west side of South Main Street near Boonsboro's town square. (Courtesy of the Boonsborough Museum of History.)

Coauthor Doug Bast wears a top hat and an easy grin while conducting a tour of his Boonsborough Museum of History at 113 North Main Street in the 1980s. Bast also owned Bast of Boonsboro, Maryland's oldest continually operating retail furniture store, until it closed its doors in 2011 after 174 years of service. Located at 109 North Main Street, the large Bast of Boonsboro furniture store began as Brining's Cabinet Shop in 1837. The Boonsborough Museum of History has been serving residents as a private, nonprofit institution since 1974. (Courtesy of the Boonsborough Museum of History.)

Three

THE MOUNTAIN

Holding an early-1900s wool flat cap and wearing a dress suit, dress shoes, and bow tie, this man and his family pose in their Sunday best on a large rock beside Noah's Falls on the western slope of the South Mountain range about two miles southeast of Boonsboro. The man is thought to be a Mr. Bender or a Mr. Gilbert, who made rugs and operated a retail store in Boonsboro. (Courtesy of the Boonsborough Museum of History.)

Dahlgren Chapel, seen here in a mid-1900s photograph by C.M. Hewitt of Middletown, Maryland, stands among the trees on the north side of the National Road (Alternate US Route 40) at Turner's Gap, about three miles southeast of Boonsboro. Completed in 1884 by Madeleine V. Dahlgren, the wife of Civil War admiral John A. Dahlgren, the private stone chapel is across from the Dahlgren Manor residence, which served as Confederate general Daniel Harvey Hill's headquarters during the 1862 Battle of South Mountain. (Courtesy of the Washington County Historical Society.)

A young woman stands on a rustic but sturdy gully bridge near Noah's Falls on the western slope of South Mountain about two miles southeast of Boonsboro in the early 1900s. Farther up the path, a man wears a sport jacket and stiff, straw boater hat, a woman is in a full-length skirt, and drinking spring water from a cup, a boy is seen in a coat and short pants. (Courtesy of the Boonsborough Museum of History.)

Visitors stand atop the Washington Monument and its canopy following the monument's first major reconstruction on South Mountain near Boonsboro in 1882. Initially completed by the citizens of Boonsboro in 1827, the 34-foot-tall edifice was rebuilt to its present form in 1936, and today is the centerpiece of Maryland's 169-acre Washington Monument State Park. (Photograph by E.M. Recher; courtesy of the Washington County Historical Society.)

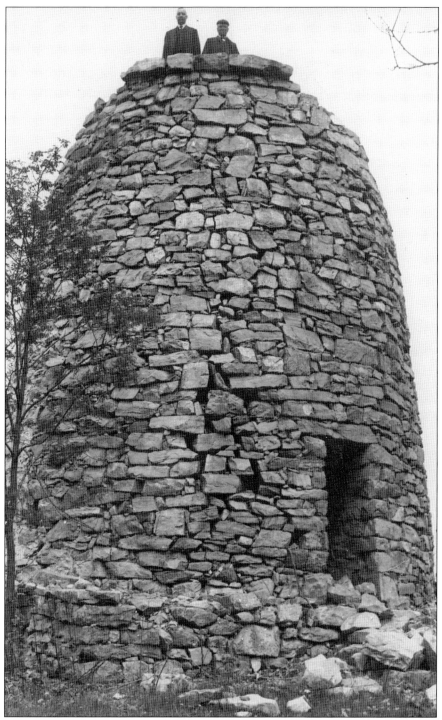

Two men stand on top of South Mountain's Washington Monument as it shows the deterioration it suffered in the early 1900s. The 1827 monument was rebuilt in 1936. Boonsboro's Independent Order of Odd Fellows organization had led another earlier monument reconstruction effort in 1882. (Photograph by C.D. Young; courtesy of the Boonsborough Museum of History.)

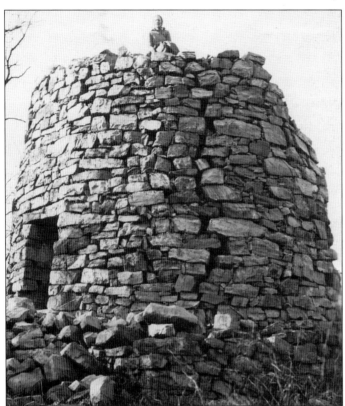

A woman sits above a large crack in the wall of the crumbling Washington Monument in about 1915. First completed by the citizens of Boonsboro in 1827, the first monument to the first US president underwent extensive reconstructions in 1882 and in 1936. (Courtesy of the Washington County Free Library.)

Music-makers mingle with audience members during Washington Monument rededication ceremonies on July 4, 1936. The monument was rebuilt during the Great Depression by the Civilian Conservation Corps (CCC). (Courtesy of the Boonsborough Museum of History.)

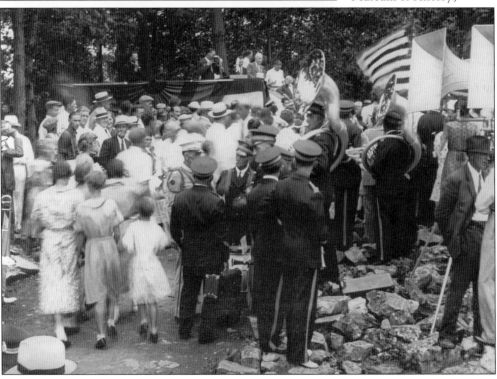

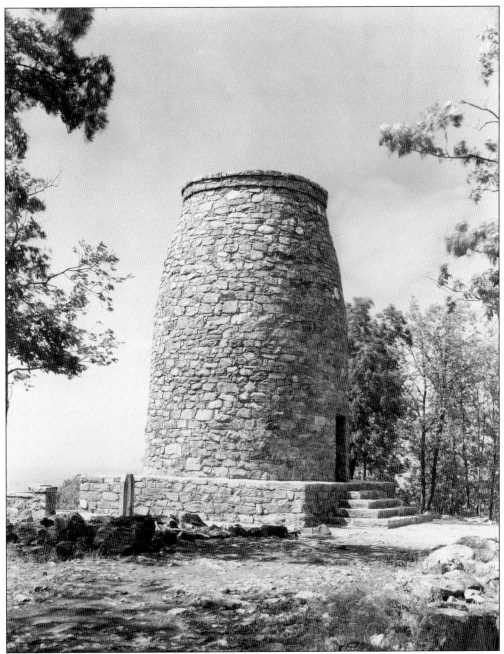

Sunshine warms the west side of the Washington Monument—at an elevation of 1,500 feet on South Mountain—following the monument's 1936 reconstruction by the CCC. The monument served as a Union army signal station during the Battles of South Mountain and Antietam in September 1862. Today, the Appalachian National Scenic Trail passes nearby, and the monument has become a central landmark for the four state parks that make up Maryland's South Mountain Recreation Area. (Courtesy of the Washington County Free Library.)

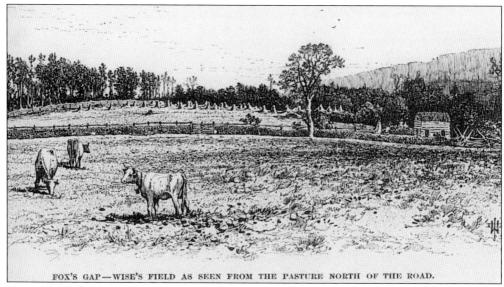

FOX'S GAP—WISE'S FIELD AS SEEN FROM THE PASTURE NORTH OF THE ROAD.

Viewed from the National Road near Fox's Gap, southeast of Boonsboro, Daniel Wise's farm fields and home were engulfed by Civil War fighting during the September 14, 1862, Battle of South Mountain. Dumped by a Union burial detail after the battle, the bodies of 58 Confederate soldiers remained in Wise's well for 12 years before being reinterred in the Washington Confederate Cemetery in Hagerstown. (Courtesy of the South Mountain State Battlefield.)

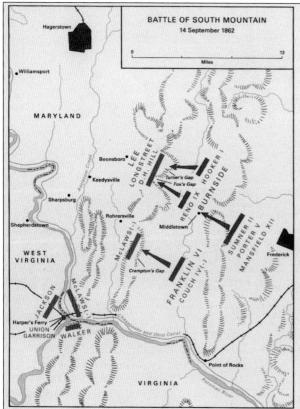

This overview map puts Boonsboro near the front lines of the Civil War Battle of South Mountain on September 14, 1862. The battle lines in the lower left show Confederate general Thomas "Stonewall" Jackson capturing the Union garrison at Harpers Ferry. Union troops are forcing their way across the South Mountain range (center) at Turner's, Fox's, and Crampton's Gaps. Three days later, the Battle of Antietam became the bloodiest single-day battle in American history. (Courtesy of the US Army Center of Military History.)

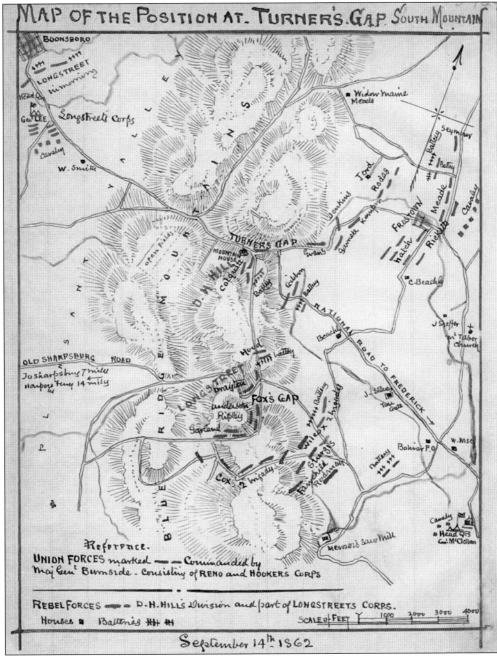

MAP OF THE POSITION AT TURNER'S GAP SOUTH MOUNTAIN

September 14th 1862

In this hand-drawn map of the Battle of South Mountain, Confederate general Robert E. Lee's headquarters are just south of Boonsboro (upper left), and Union general George B. McClellan's headquarters are just south of Bolivar (lower right). Fighting at Turner's Gap (upper center) and Fox's Gap (lower center) and farther south at Crampton's Gap produced 6,000 casualties and served as a prelude to the Battle of Antietam, which left 23,110 casualties three days later near Sharpsburg, about six miles west of Boonsboro. Union private Robert Knox Sneden (1832–1918) produced 300 battlefield pen-and-ink and watercolor maps like this one before he was captured in 1863. (Courtesy of the Library of Congress and the Virginia Historical Society.)

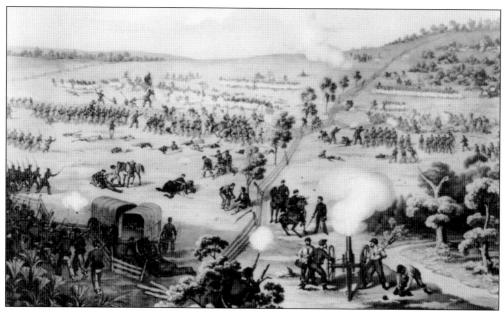

In this painting by 19th-century artist A.A. Fasel, Union troops and artillery attack Confederate positions at Fox's Gap during the September 14, 1862, Battle of South Mountain. The South Mountain fighting served as a prelude to the bloodiest single-day military battle in American history on September 17, 1862, at Sharpsburg six miles west of Boonsboro. (Courtesy of the Library of Congress.)

The "loyal ladies of Boonsboro and vicinity" receive high praise in this November 27, 1861, Hagerstown newspaper article extolling their "noble" two-week effort to "box up" $400 worth of articles "for the relief of the sick and wounded of our armies." Among the items gathered were 19 blankets, 17 quilts, 50 towels, 18 sheets, 55 flannel shirts, 51 pairs of yarn socks, 30 jars of preserves and jellies, 61 bags of dried fruit, and 118 pounds of soap. (Courtesy of the Washington County Free Library.)

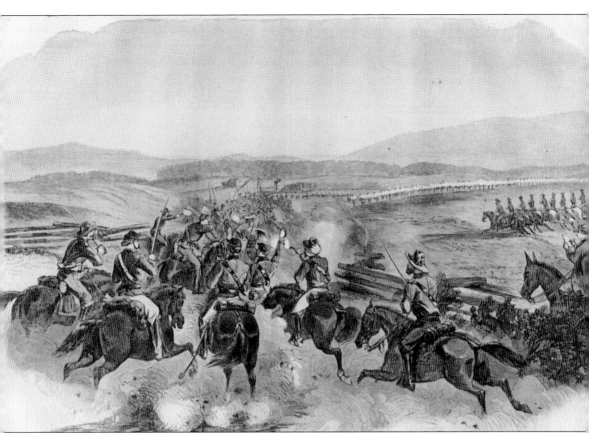

Cavalry units converge along the National Pike north of Boonsboro on July 8, 1863, during what is considered the second-largest cavalry battle of the Civil War. Troops led by Union general John Buford and Confederate general J.E.B. Stuart clashed during Confederate commander Robert E. Lee's retreat from the three-day Battle of Gettysburg on July 1–3, 1863. (Courtesy of the South Mountain State Battlefield.)

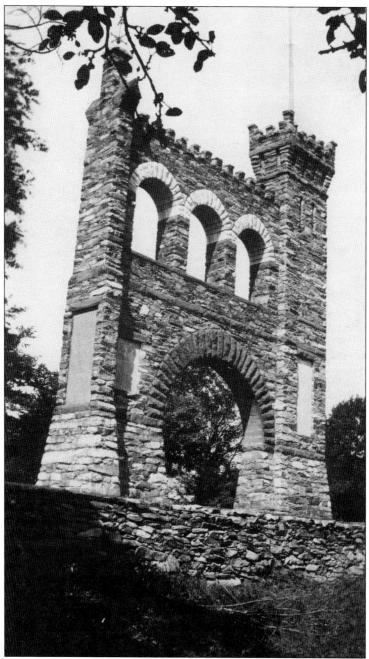

This 1922 east-facing photograph by Civil War historian Fred Wilder Cross shows the tower, arches, and three of the recessed plaques on George Alfred Townsend's castle-like 1896 War Correspondents Arch at Crampton's Gap atop the South Mountain range. Adjacent to the Appalachian National Scenic Trail, the popular Maryland landmark is a National Historic Monument maintained by the National Park Service. Townsend dedicated his monument as follows: "To the Army correspondents and artists 1861–65 whose toils cheered the fireside, educated provinces of rustics into a bright nation of readers, and gave incentive to narrate distant wars and explore dark lands." (Courtesy of the Boonsborough Museum of History.)

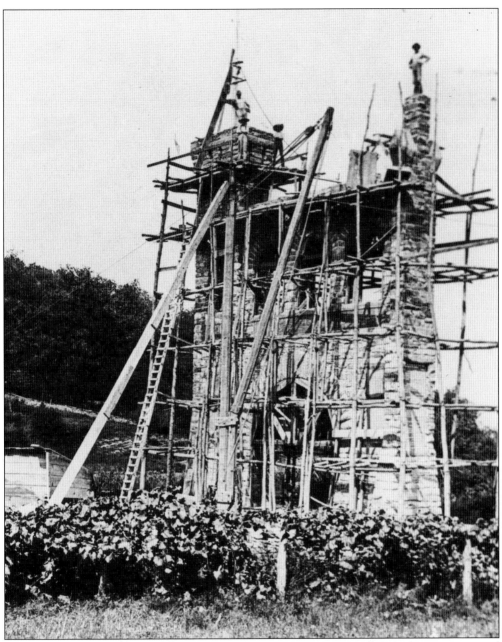

Workers stand atop George Alfred Townsend's War Correspondents Arch as it is being constructed in 1896 on his South Mountain estate at Crampton's Gap. A popular novelist, Townsend was the youngest newspaper field correspondent in the American Civil War. He lived from 1841 to 1914; his estate is now a popular state park. (Courtesy of the Washington County Free Library.)

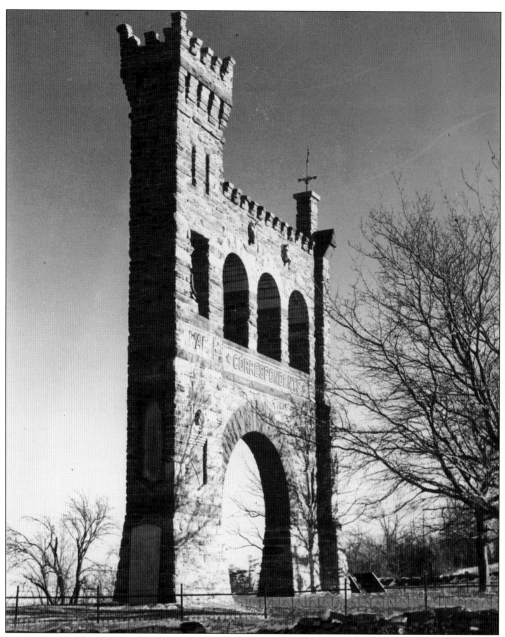

Sun shines on the west face of George Alfred Townsend's castle-like War Correspondents Arch in Gathland State Park on South Mountain in the mid-1900s. The memorial arch is 50 feet high and 40 feet wide. Three nine-foot-tall arches representing "Description, Depiction, and Photography" stand above a 16-foot-tall offset base arch on the south end of the monument. A statue of the Greek god Pan is inset into a taller tower on the north side. The word "War" appears midway up the tower while the word "Correspondents" appears between two stars midway up the arch side of the monument. Included among the memorial arch's eclectic collection of carvings are tablets containing the names of 157 correspondents and war artists who, according to Townsend biographer Ruthanna Hindes, "saw and described in narrative and picture almost all the events of the four years of the war." (Courtesy of the Washington County Free Library.)

Four

THE AREA

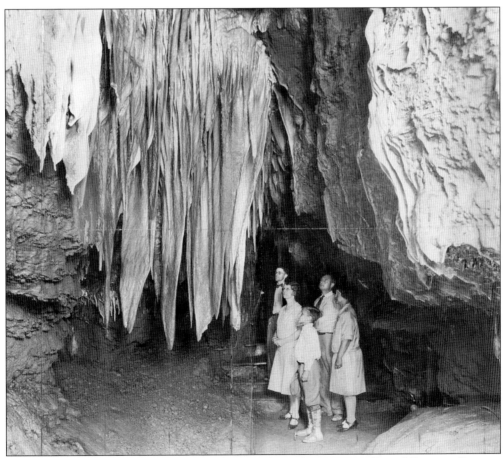

Visitors in this 1930s photograph study underground cave formations at Crystal Grottoes Caverns, found about a mile west of Boonsboro on the south side of Route 34. The only commercial cave in Maryland, Crystal Grottoes is one of the largest in the state. It was discovered in 1920 as a result of quarry operations for road material. (Courtesy of the Boonsborough Museum of History.)

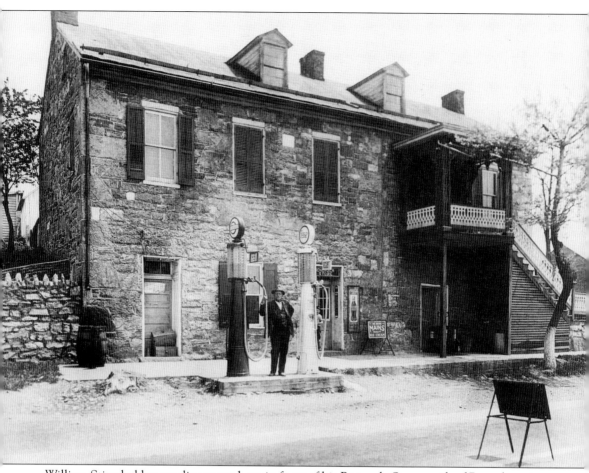

William Stine holds a gasoline pump hose in front of his Benevola Store north of Boonsboro in about 1940, which was when Esso gasoline was 16.9¢ per gallon. Stine operated his store in this historic stone building on the east side of the National Road from 1928 until he died in 1952. (Courtesy of Ruann Newcomer George.)

This 19th-century painting, "Residence of D.H. Newcomer, Benevola, Md.," depicts two horsemen who have stopped to chat on the National Road in the crossroads village about three miles north of Boonsboro. D.H. Newcomer was a state senator who owned a 400-acre Benevola farm in 1877. The landmark Newcomer's Mill is the white three-story building on the far left. (Courtesy of Ruann Newcomer George.)

Sometimes known as Benevola Mill, Newcomer's Mill, with its the stone-and-wood frame, had several broken windows and other evidence of neglect shortly before it was demolished in 1920. Stone from the 19th-century mill was used to build a bungalow residence that stands on the site of the old mill. (Courtesy of Ruann Newcomer George.)

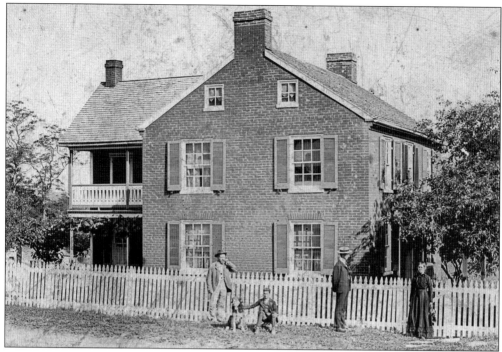

Pictured around 1905, on the sunny side of the Newcomer farmhouse in Benevola, are, from left to right, Henry Newcomer, Elmer Newcomer, Harry Newcomer, and Louisa Jane Harp Newcomer. The historic farmhouse is on the north side of the Benevola Newcomer Road just west of the Old National Pike. (Courtesy of Ruann Newcomer George.)

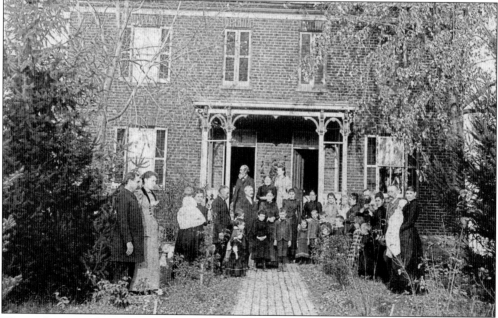

Thirty-three members of the Joshua Harp family gathered in front of his brick Benevola home north of Boonsboro in 1892. Harp was a founding trustee of Benevola's United Brethren in Christ Church in 1858. (Courtesy of Ruann Newcomer George.)

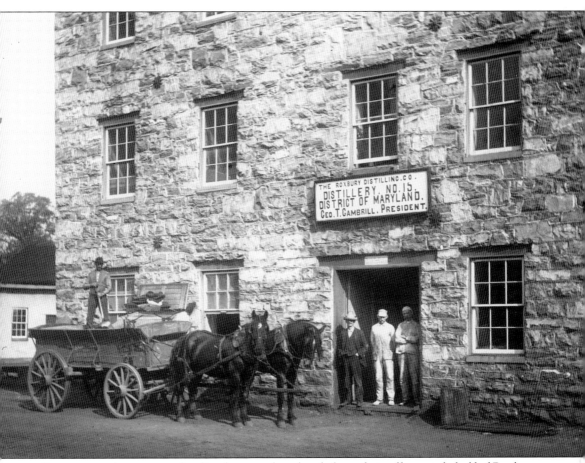

Four men and two wagon-hauling horses take a break from their efforts on behalf of Roxbury Distilling Company's distillery No. 15 near Boonsboro in about 1910. The multibuilding distillery complex was located on the site of a former 19th-century gristmill along both sides of Roxbury Road just west of the Antietam Creek. (Courtesy of the Boonsborough Museum of History.)

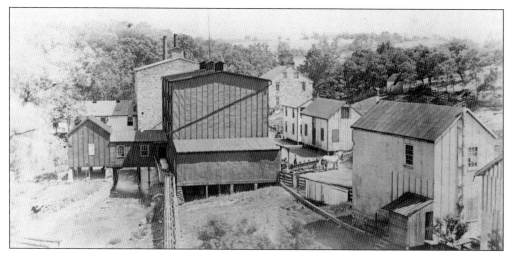

An overhead view reveals at least seven distillery buildings at the Roxbury Distilling Company complex northwest of Boonsboro in about 1910. Now in almost total ruins, the distillery complex was located on Roxbury Road just west of an 1824 stone bridge across the Antietam Creek. (Courtesy of the Boonsborough Museum of History.)

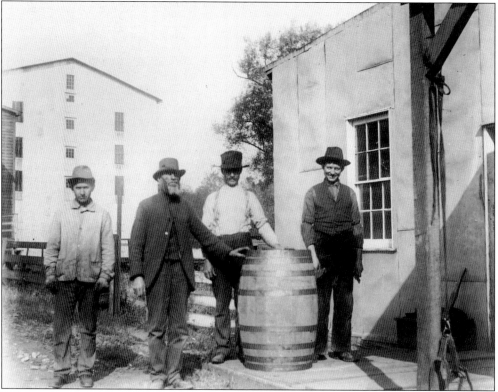

Four employees pose with a barrel of whiskey at the Roxbury Distilling Company complex on Roxbury Road northwest of Boonsboro in about 1910. With an office in Baltimore, company president George T. Gambrill operated his business as the Roxbury Distillery from 1892 to 1902 and as Roxbury Distilling Company from 1903 to 1913. (Courtesy of the Boonsborough Museum of History.)

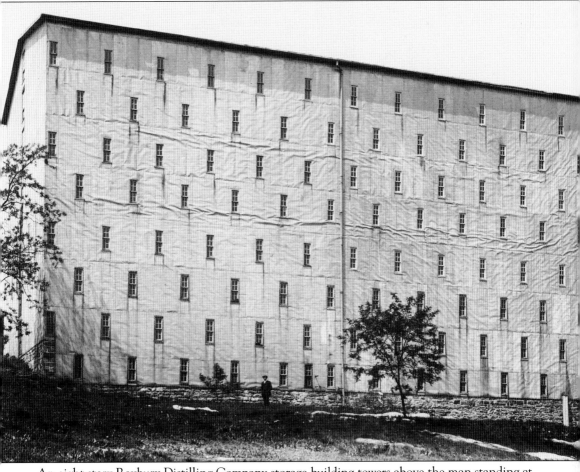

An eight-story Roxbury Distilling Company storage building towers above the man standing at the bottom center of this 1910 photograph of the distillery site on Roxbury Road northwest of Boonsboro. The storage building was destroyed by fire. The multibuilding distillery site was in operation from 1892 to 1913. (Courtesy of the Boonsborough Museum of History.)

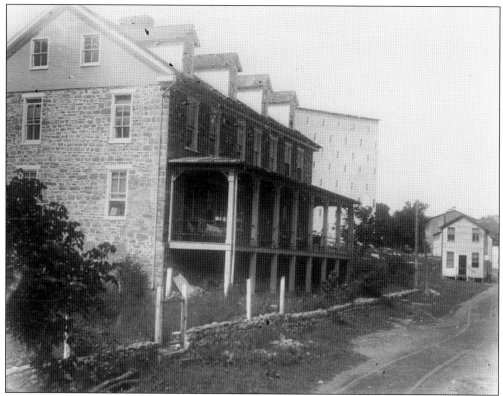

A four-dormer stone building faces the road leading to the Roxbury Distilling Company near Boonsboro about 1910. The multibuilding whiskey-distilling, sales, and storage complex was located on the site of a former 19th-century gristmill along both sides of Roxbury Road. (Courtesy of the Boonsborough Museum of History.)

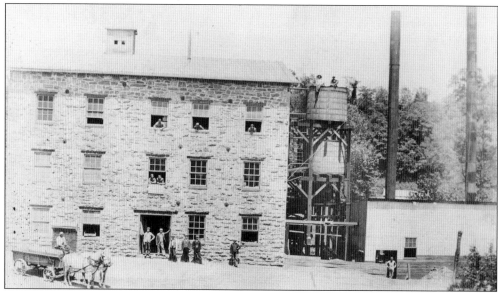

Workers gather around a main building and water towers at the Roxbury Distilling Company around 1911. (Courtesy of the Boonsborough Museum of History.)

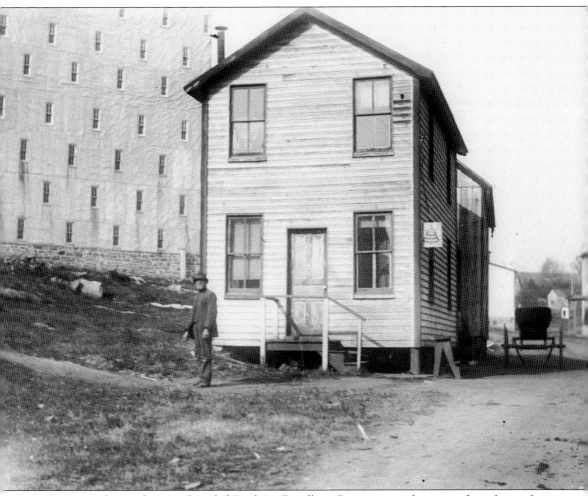

Wearing a hat and coat, a bearded Roxbury Distilling Company employee stands in front of a company office building showing the latest telephone availability sign in about 1910. A horseless buggy is parked to the right of the office building. The distillery's eight-story storage building looms uphill to the left. (Courtesy of the Boonsborough Museum of History.)

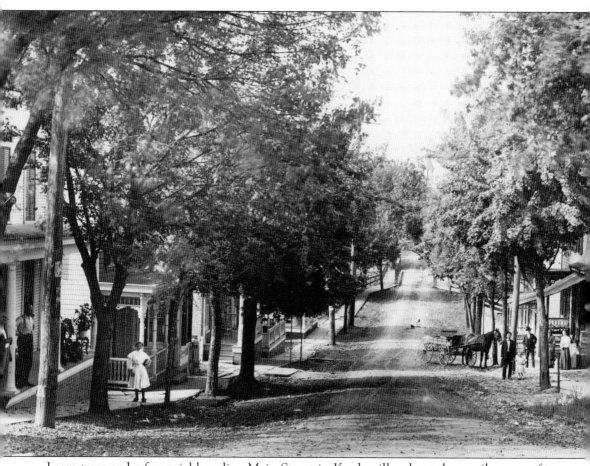

Large trees and a few neighbors line Main Street in Keedysville, about three miles west of Boonsboro, in the late 1800s. Tracing its origins to 1768, Keedysville was incorporated in 1872. The population of today is nearly 800. (Courtesy of the Boonsborough Museum of History.)

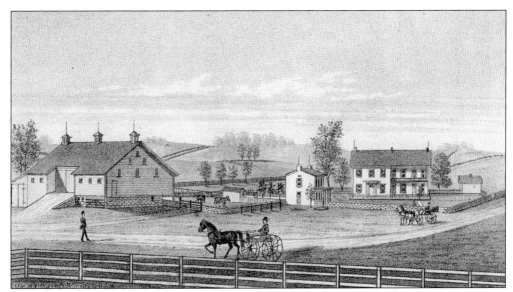

A pedestrian and two horse-drawn carriages make their way along Mapleville Road north of Boonsboro in "Residence of Mrs. Amy Fahrney," an etching that appears in the 1877 historical reference book *An Illustrated Atlas of Washington County, Maryland.* (Courtesy of the Washington County Historical Society.)

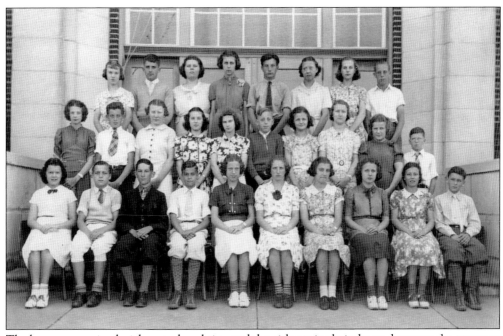

The boys are wearing knickers and neckties, and the girls are in their dressy dresses at the entrance to the former Boonsboro High School on the east side of north Main Street. There are 18 girls and 10 boys in this c. 1940 photograph of classmates. (Courtesy of the Boonsborough Museum of History.)

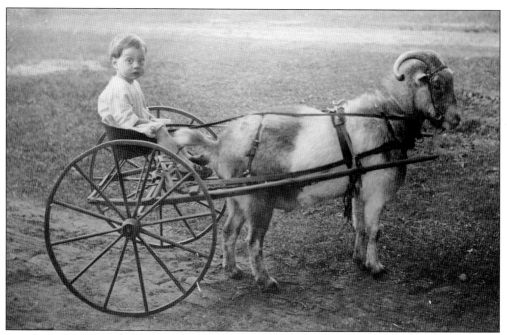

A wide-eyed youngster holds the reins of a goat-cart ride offered by the Stine Amusement Company in Trego, about six miles south of Boonsboro, in the early 1900s. Specializing in carousels, company owner T.L. Stine offered a variety of "amusements for parks." His wares often found their way to the Baltimore-Washington metropolitan area. (Courtesy of the Boonsborough Museum of History.)

Sporting his trademark moustache, T.L. Stine was the owner of Stine's Carousels in the early 1900s. Based south of Boonsboro in the village of Trego, Stine's entertainment and manufacturing ventures also included the latest developments in phonographs and bathtubs. (Courtesy of the Boonsborough Museum of History.)

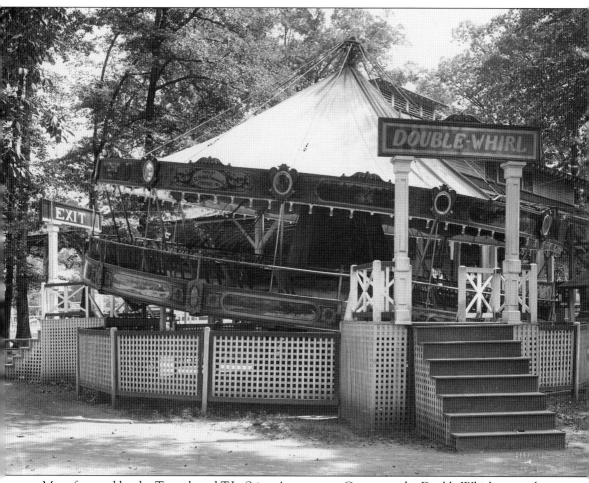

Manufactured by the Trego-based T.L. Stine Amusement Company, the Double-Whirl carousel spun in about 1920 in "wave-like motions never before attempted." The company advertised itself as a "general amusement outfitter" that gives special attention to picnics, celebrations, and conventions. (Courtesy of the Boonsborough Museum of History.)

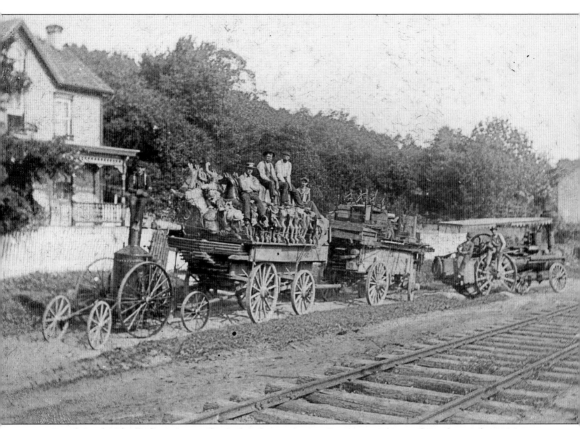

Ready to haul all the pieces of a Stine Amusement Company carousel in the early 1900s are, from left to right, Harry Easton, sitting on top of the carousel's steam engine; Herb Stine, the company owner's son; T.L. Stine, the owner; unidentified; Daisy ?; and two unidentified operators of the locomotive-like hauling steam engine at right. (Courtesy of the Boonsborough Museum of History.)

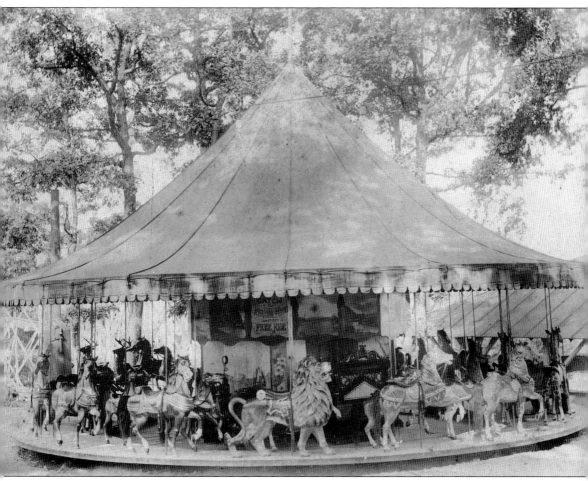

This sun-drenched T.L. Stine carousel features lions, giraffes, and reindeer in addition to the usual horses. "Catch the brass ring and get a free ride," advises a sign under the ride's awning. A dealer and operator of carousels, T.L. Stine maintained a wide-ranging amusement business south of Boonsboro in the village of Trego in the early 1900s. (Courtesy of the Boonsborough Museum of History.)

This historical Newcomer family barn is on the north side of the Benevola Newcomer Road just west of the Old National Pike. (Courtesy of Ruann Newcomer George.)

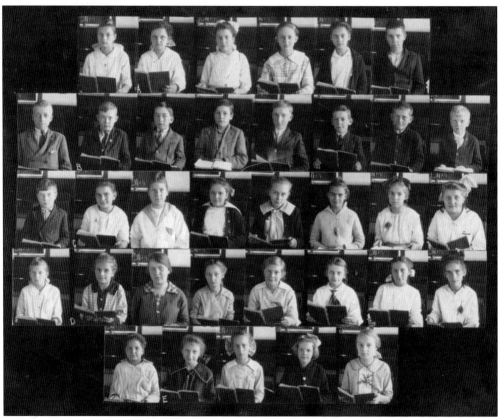

A photographer's proof sheet captures these 35 Boonsboro-area classmates in the early 1900s. There are 25 girls and 10 boys in this group of public school students. (Courtesy of the Boonsborough Museum of History.)

Employee Tom Smith stands outside McCoy's Marble Works in Rohrersville, five miles south of Boonsboro, in about 1900. Marble Works founder G. Washington McCoy had organized the Rohrersville Cornet Band of Washington County in 1837. A brick Rohrersville Band Hall building replaced the wood frame McCoy's Marble Works building in 1916, according to band historian Richard Haynes. The Rohrersville band is Maryland's oldest community band in continuous existence. (Courtesy of the Boonsborough Museum of History.)

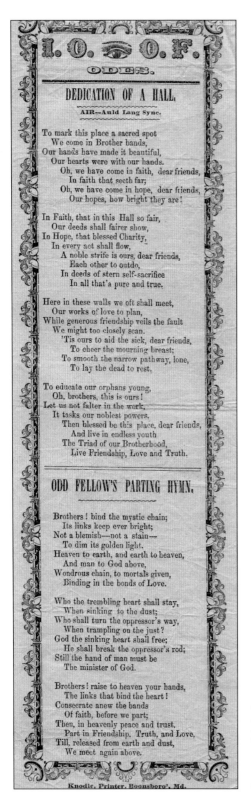

I.O. O.F.
ODES.

DEDICATION OF A HALL,

AIR--Auld Lang Syne.

To mark this place a sacred spot
 We come in Brother bands,
Our hands have made it beautiful,
 Our hearts were with our hands.
 Oh, we have come in faith, dear friends,
 In faith that seeth far;
 Oh, we have come in hope, dear friends,
 Our hopes, how bright they are!

In Faith, that in this Hall so fair,
 Our deeds shall fairer show,
In Hope, that blessed Charity,
 In every act shall flow,
 A noble strife is ours, dear friends,
 Each other to outdo,
 In deeds of stern self-sacrifice
 In all that's pure and true.

Here in these walls we oft shall meet,
 Our works of love to plan,
While generous friendship veils the fault
 We might too closely scan.
 'Tis ours to aid the sick, dear friends,
 To cheer the mourning breast;
 To smooth the narrow pathway, lone,
 To lay the dead to rest.

To educate our orphans young,
 Oh, brothers, this is ours!
Let us not falter in the work,
 It tasks our noblest powers,
 Then blessed be this place, dear friends,
 And live in endless youth
 The Triad of our Brotherhood,
 Live Friendship, Love and Truth.

ODD FELLOW'S PARTING HYMN,

Brothers! bind the mystic chain;
 Its links keep ever bright;
Not a blemish—not a stain—
 To dim its golden light.
Heaven to earth, and earth to heaven,
 And man to God above,
Wondrous chain, to mortals given,
 Binding in the bonds of Love.

Who the trembling heart shall stay,
 When sinking to the dust;
Who shall turn the oppressor's way,
 When trampling on the just?
God the sinking heart shall free;
 He shall break the oppressor's rod;
Still the hand of man must be
 The minister of God.

Brothers! raise to heaven your hands,
 The links that bind the heart!
Consecrate anew the bands
 Of faith, before we part;
Then, in heavenly peace and trust,
 Part in Friendship, Truth, and Love,
Till, released from earth and dust,
 We meet again above.

Knodle. Printer. Boonsboro'. Md.

This Independent Order of Odd Fellows parting hymn and ode to the dedication of a new Odd Fellows hall were printed by renowned Boonsboro printer Josiah Knodle around 1900. (Courtesy of the Boonsborough Museum of History.)

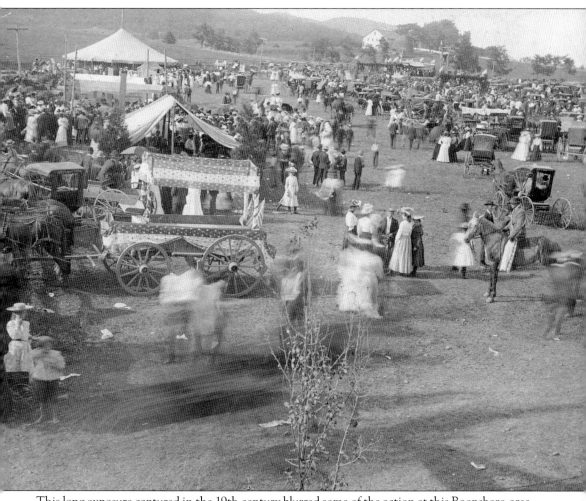

This long exposure captured in the 19th century blurred some of the action at this Boonsboro-area country fair. (Courtesy of the Boonsborough Museum of History.)

Advertisers from Hagerstown to Westminster and Keedysville to Sharpsburg paid for space on this page in the 1940 Boonsboro High School yearbook. (Courtesy of the Boonsborough Museum of History.)

124

A smiling unidentified woman displays a collection of Boonsboro's famous Hearts of Gold cantaloupes for a 1959 photograph by James B. Minnich of the Fairchild Aircraft Company in Hagerstown. The Hagerstown Chamber of Commerce acquired Minnich's photograph and used it for promotional purposes. (Courtesy of the Washington County Free Library.)

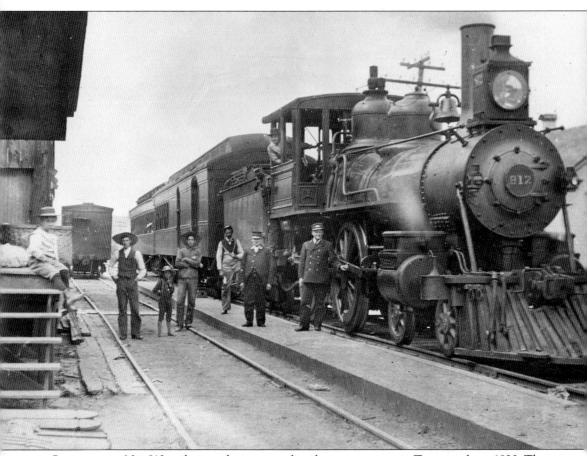

Steam engine No. 812 and nine admirers stand at the train station in Trego in about 1920. The engine appears ready to head up the line with a mail car and a passenger car while an unattached freight car awaits a connection on a separate set of tracks. (Courtesy of the Boonsborough Museum of History.)

Standing for this c. 1890 Baltimore studio photograph is a steely-eyed favorite fighting gamecock from the village of Friendly Hall or Magnolia, south of Boonsboro. With man-made fighting spurs attached to his legs, the favored foul appears ready for a match. The photographic studio owner, John Philip Blessing, was an active photographer in Baltimore from 1880 to 1904, according to authors Peter Palmquist and Thomas Kailbourn. Blessing also maintained a separate studio from 1899 to 1901 in the southern Washington County village of Brownsville, where his parents had been married in 1824. (Photograph by Blessing and Company; courtesy of the Boonsborough Museum of History.)

Discover Thousands of Local History Books
Featuring Millions of Vintage Images

Arcadia Publishing, the leading local history publisher in the United States, is committed to making history accessible and meaningful through publishing books that celebrate and preserve the heritage of America's people and places.

Find more books like this at
www.arcadiapublishing.com

Search for your hometown history, your old
stomping grounds, and even your favorite sports team.

Consistent with our mission to preserve history on a local level, this book was printed in South Carolina on American-made paper and manufactured entirely in the United States. Products carrying the accredited Forest Stewardship Council (FSC) label are printed on 100 percent FSC-certified paper.

MADE IN THE USA